D1486929

PUBLIC ART SAINT PAUL PRESENTS **THE**

WING YOUNG HUIE

UNIVERSITY AVENUE PROJECT

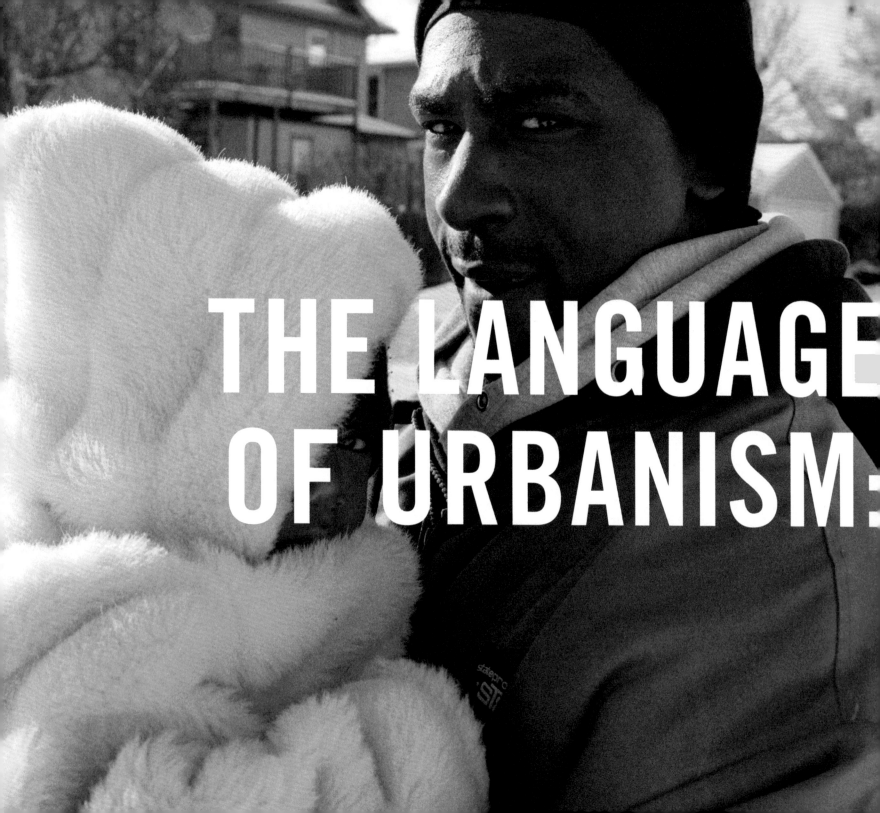

THE LANGUAGE OF URBANISM:

PUBLIC ART SAINT PAUL PRESENTS

THE UNIVERSITY AVENUE PROJECT

VOLUME TWO

A SIX-MILE PHOTOGRAPHIC INQUIRY

WING YOUNG HUIE

MINNESOTA HISTORICAL SOCIETY PRESS

"IT GOES BEYOND THE USUAL GOALS O

LOGIC OF DOCUMENTARY PHOTOGRAPH

—RECORDING PEOPLE AND EVENTS—

TO STRESS THE POWER OF PHOTOGRAPH

IC IMAGES TO BUILD CONNECTIONS, T

CREATE AND REFLECT RELATIONSHIPS.

F
614
.54
H86
2010
v.2

FROM DOCUMENTARY PHOTOGRAPHY TO RELATIONAL AESTHETICS

The University Avenue Project and Wing Young Huie

Patricia Briggs, PhD

Like all signs or texts, photographs are complex constructions, written and rewritten with every viewing. Context matters a great deal. It shapes the ways we see photographs.

Is the photograph printed on a driver's license, framed and hung in a commercial art gallery, or projected on the side of a public building? The context in which a photograph is presented dictates the social interactions it produces, creates, or instigates. A driver's license photograph, pulled from a wallet, satisfies the bureaucracy's need for tangible proof of identity. The same image framed in an art gallery invites a lone viewer to contemplate silently, to think about entirely different things. Projected on a building after dark, the very same photograph might cause a group to form, conversations to develop.

The University Avenue Project embraces the idea that art exists at the intersection of image, context, and viewer. Its power lies in conversation and connection.

Installation view, Project(ion) Site.
Photo by Christine Podas-Larson

It goes beyond the usual goals or logic of documentary photography—recording people and events—to stress the power of photographic images to build connections, to create and reflect relationships.

POLITICS AND MEANING IN DOCUMENTARY PHOTOGRAPHY

With *The University Avenue Project,* a six-mile-long exhibition on a busy street in Saint Paul, Minnesota, artist Wing Young Huie reminds us that although photographs seem to be passive records of reality, their meaning is

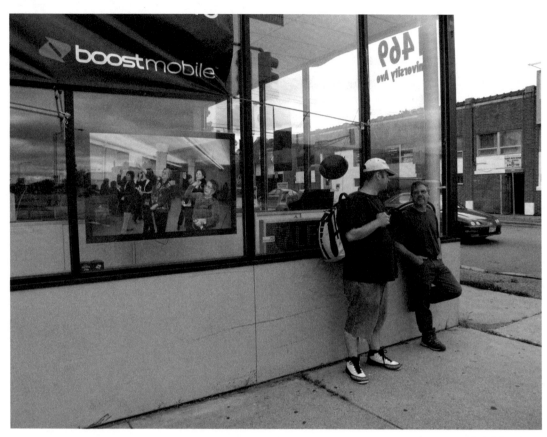

Installation view

anything but straightforward. A photographer's conscious and unconscious intentions, his or her perspective or point of view, influence the images he or she creates. This is as true of more overtly artistic photography—for example Alfred Stieglitz's pictorialist cloud studies or Ansel Adams's picturesque landscapes—as it is for documentary-style photography and photojournalism, which form the aesthetic DNA of *The University Avenue Project*.

Consider for example the work of Jacob Riis, a pioneer of the documentary style who photographed the urban poor

in New York City's crowded tenements in the late 1800s and early 1900s.[1] Riis's gritty, realist black and whites present themselves as if they are unedited and unconstructed records of everyday life. Yet like all photographs, Riis's were carefully designed. Riis chose his subjects and directed them on how to pose. Later, he carefully selected and arranged images for publication. All of this helped support the photographer's ideological position on social reform.

Riis isolated his subjects to make them appear vulnerable. In an interesting contrast to Wing Young Huie's work, Riis

favored photographing his subjects looking away from the camera, as if the people were too listless to exchange glances with him or with the intended viewers. Riis's photographs are less a truthful record of life than they are signposts meant to communicate ideas on social reform to a specific audience—the relatively affluent people who were most likely to view the published images.

If Riis's images of crowded tenements show the potential of documentary photography to promote social reform, then the work of Edward S. Curtis is emblematic of how race and politics can converge in the documentary image. Curtis, a contemporary of Riis, turned an anthropological gaze toward the native people of the American West. The faces that stare out from his photographs raise many questions. Did Curtis's subjects realize that their images would become iconic of "Indian-ness" as understood by white viewers? Did they know that Curtis's photographs would be consumed by generations of white audiences, as hungry to colonize Indian culture as they were to colonize tribal lands?[2]

More recently, photographs of dark-skinned bodies in the pages of *National Geographic Magazine* are presented to (primarily white) readers as being the objective record of a particular culture. But the photographic essays are in fact framed and edited to meet the expectations of a white, Western audience. They reinforce accepted ideas about "primitive" or "exotic" non-Western people.[3]

Documentary photographers frequently disempower the people they frame, reinforcing ideas about what's "normal" or "acceptable" within a culture or society.[4] The very act of capturing a person's image often serves to highlight the difference between the social norms and beliefs held by the photographer and those held by the subject. Photographs representing difference, deviance, or poverty—those featuring Indians, Africans, African-Americans, addicts, street people, drag queens, and

others—inadvertently spotlight the power held by the person with the camera and the power exerted by the people who eventually view the images hanging on a gallery wall.

Wing Young Huie is particularly aware of the seemingly inherent inequity at the heart of much documentary photography: the person holding the camera wields more control over a photograph's meaning than the person or

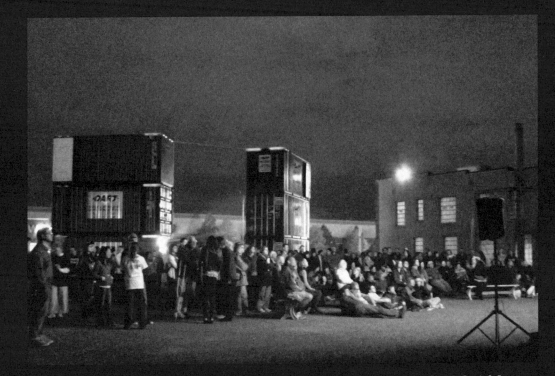

Project(ion) Site. Photo by Randy C. Bunney

persons depicted in the image. This power relationship typically mirrors cultural power imbalances of race, class, and gender. Has the person in the picture chosen to be represented or has he or she been captured in the image while unaware? Does the person know how his or her photograph will be used, published, sold, or displayed? Was the person consulted when the photographer framed or designed the shot and edited it for publication or display?

CHALLENGING NORMS

It isn't easy to take a photograph that doesn't disempower the subject. Keenly aware of the representational politics of documentary photography, Wing Young Huie critically considers every aspect of his art—from the way he interacts with his subjects, to the framing or design of individual shots, to the manner in which he presents his work to the public.

Huie, who is Chinese-American, was born and raised in a predominantly white neighborhood in Duluth, Minnesota. After moving to the Twin Cities of Minneapolis and Saint Paul, he used his camera to explore the culturally diverse neighborhoods he found around him. From the beginning, photography served Huie as a tool to uncover—one neighborhood at a time—a Minnesota that lies somewhere beyond the idea of normalcy permeating Garrison Keillor's fictional creation of Lake Wobegon.

During the 1990s, Huie first established a practice of using the camera not only as a recording device but more importantly as an instigator of interaction and engagement, as a relational tool. After the fairly intimate public art exhibition *Frogtown: Portrait of a Neighborhood* (1995), he created the large and ambitious *Lake Street USA* (2000). With *The University Avenue Project* (2010), Huie continues to use photography on a large scale to search for an understanding of his own identity, to explore the cultural landscape beyond images of normalcy and American-ness perpetuated in the media, and to counter the visual clichés of "difference" which often characterize documentary photography.

"HUIE USES THE CAMERA AS A DEVICE TO INITIATE CONVERSATION AND CONNECTION."

Importantly, the people represented in *The University Avenue Project*—the people captured in the photographs—are also Huie's intended audience for the work. Huie exhibits his work on the same streets and shops where he shoots it, deeply motivated by a desire to take art to the public and to resist and remake the traditional dynamic at work in galleries and museums (where some feel more welcome than others).

In the past, Huie has placed his photographs in storefronts, on buses, and under Plexiglas in neighborhood parks. With *The University Avenue Project,* he does much of this and goes one step further. Adapting the graffiti artist's notion of creating an underground spectacle, Huie presents hundreds of digital images on a large screen Wednesday through Sunday nights in an abandoned lot on University Avenue. No polished posters direct viewers to the projection site, and little signage announces it. Yet on those nights hundreds of images cycle by on the large screen as recorded music by local artists fills the air.

Huie consciously avoids aesthetic clichés and resists familiar formulas of documentary photography: highly graphic dark and light patterns, artful asymmetry, a telling moment captured. Instead, Huie places figures in the middle ground of the frame and pays equal attention to the space that they inhabit. Huie's focus is on both the figures and their environment. Tellingly,

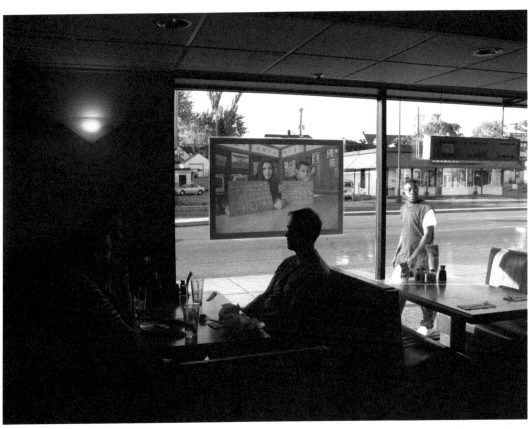

Installation view

9

that environment is what it is: a library, a parking lot, a backyard. It seems that nothing exciting or worthy of spectacle happens in these photographs. Schoolchildren sit at a lunch table. A boy gets a haircut. A man sits in a waiting room. The people just are.

Through hundreds of photographs culled from thousands of one-on-one encounters, Huie uses the camera as a device to initiate conversation and connection. In this way, he departs from much urban documentary photography in the past. In the late 1930s, Walker Evans used a camera hidden in his coat to steal shots of subway commuters in New York City. At midcentury, Robert Frank

captured people unaware, woven into the fabric of life on city streets. In contrast, Huie invites his subjects to look directly at the camera. He always asks for permission to take a photograph, always talks to the people he photographs. He wants to hear their stories. As a photographer, he is welcomed onto neighborhood basketball courts, into barbershops, Asian video stores, beauty salons, shops, mosques, and community churches.

Four teenage girls stand in an empty school parking lot in one image, happy to pose for the man they have just met. Another shot shows an African-American man holding a toddler, bundled into a winter coat, who smiles broadly

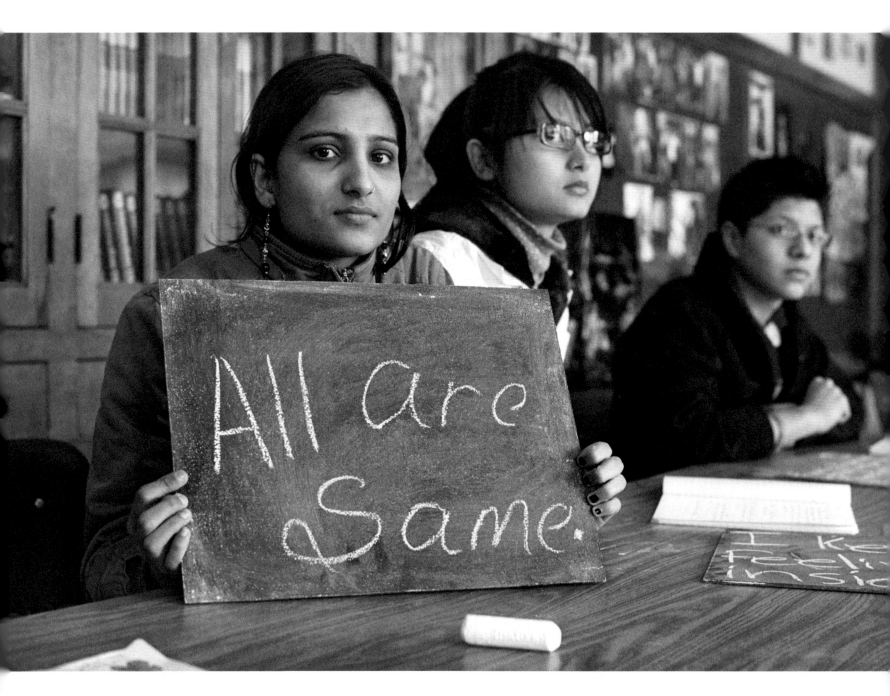

toward the photographer just a few feet away. In one photograph, two young women appear to relax in a modestly furnished apartment with their little white poodle.

One could miss the significance of the point of view employed throughout *The University Avenue Project*. It is not a vantage point that can be had from a hidden camera or by the *flaneur* who steals views as he discreetly makes his way along a city street. Instead, this is a point of view that celebrates encounter, not avoidance or fear. It strives to bring together, rather than serve the forces of class and race that can drive us apart.

New here for Huie in *The University Avenue Project* are photographs that feature individuals holding chalkboards with handwritten text. Borrowing the idea of

incorporating handwritten signboards from conceptual artists of the 1990s (who tended to use the juxtaposition of figure and text ironically), Huie adapts this strategy as a way of answering questions.

"What is your favorite word?" "What are you?" "How do you think others see you?" "How has race affected you?" The chalkboard pictured in one photograph reads "all are same." A tough-looking white girl shown in another image holds a chalkboard scrawled with the words "A Bitch. I'm really vulnerable." A black guy in a baseball cap writes simply "stay positive." By inviting his subjects to write messages on the chalkboards, Huie not only enhances and encourages connections, he also challenges photography's seemingly inherent tendency to objectify and silence its subjects. The resulting

combinations of people and words are poetic, ambiguous, and often unexpected. Yet, the written words communicate a great deal, turning Huie and the people who appear in his photographs into true collaborators.

RELATIONAL ART
It is difficult to understate the collaborative effort behind an exhibition like *The University Avenue Project*. In this sense, Wing's work fits firmly into the stream of contemporary relational art, which focuses on the collaborative experience, not just as a work of art is made but as it is viewed. Relational art encourages viewers to come together as a community, seeing, enjoying, and consuming art as part of a group. It's not so much about the one-of-a-kind *objet d'art* for a gallery, something to be seen in solitary, silent contemplation, a thing to be bought or sold.

The New York–based conceptual artist Rirkrit Tiravanija, for example, creates relational art experiences in galleries by inviting people to share a simple meal. At the end of the evening, Tiravanija leaves some trace of the event in the gallery—cooking pots or empty bottles and takeout containers. These understated objects carry a poignant message about community and the importance of human relationships.[5]

American Mark Dion is another contemporary artist who engages in relational art. His *Tate Thames Dig*,

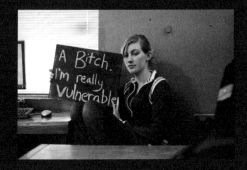

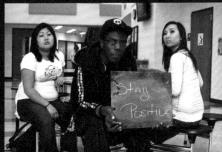

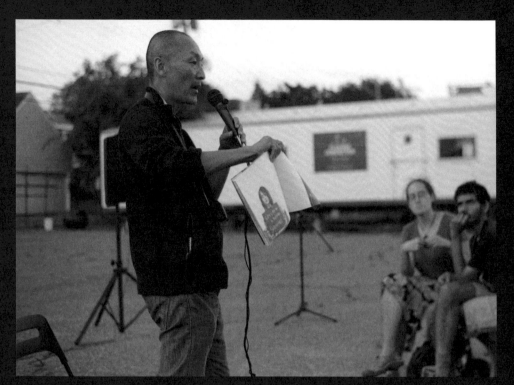

Wing Young Huie at the Project(ion) Site. Photo by Lanny Linehan

While *The University Avenue Project* is the product of enormous amounts of collaboration and planning, it still relies largely on chance. Even after years of shooting images, editing the choices, and working with countless people, Huie's exhibition does not offer a predictable experience.

Chance, the most difficult quality to retain, is the project's true strength. Huie's vision stays fresh, derived from an honest connection with others, from the unpredictable intersection of lives that converge in this space, and from the chance interactions that can only really happen while walking on a street.

NOTES

1. Abigail Solomon-Godeau, "Who Is Speaking Thus: Some Questions for Documentary Photography," in *Photography at the Dock: Essays on Photographic History, Institutions, and Practices* (Minneapolis: University of Minnesota Press, 1991), 169–83. Riis's photographs appeared in his 1890 book, *How the Other Half Lives*. My discussion of Riis's work is drawn from Solomon-Godeau's essay, pages 174–76.

2. Christopher M. Lyman, *The Vanishing Race and Other Illusions: Photographs of Indians by Edward S. Curtis* (Washington, DC: Smithsonian Institution Press, 1982).

3. The classic text on this issue is Edward Said, *Orientalism* (New York: Pantheon, 1978).

4. Tamar Y. Rothenberg, *Presenting America's World: Strategies of Innocence in* National Geographic Magazine, *1888–1945* (Burlington, VT: Ashgate Publishing Company, 2007).

5. Nicolas Bourriaud, *Relational Aesthetics* (Dijon, France: Les Presses du Reel, 2002); Miwon Kwon, *One Place After Another: Site-Specific Art and Locational Identity* (Cambridge, MA: MIT Press, 2004).

for example, brought a team of volunteers to excavate shoreline along the Thames River in London near Tate Britain (formerly the Tate Gallery). The result was a cabinet of curiosities ironically filled with cast-off rubber bicycle wheels, plastic twizzle sticks, and rusted bottle caps. All were accompanied by a video documentary showing the excavation. The project represented thousands of individual discoveries about local history embedded in the environment.

A similar sensibility to that found in Tiravanija's shared meals and Dion's community-based archaeology fuels *The University Avenue Project*. The photographs function as records of life to be sure, yet the emphasis is on the relational and the experiential. Individual shots in shop windows create opportunities for shared experiences through one-on-one encounters on the street. When the photographs appear at night, projected to the public on a huge screen, they fuel even more connections, attracting a different mix of people every time.

The University Avenue Project involves community participation and collaboration on a grand scale. Hundreds of community members who appear in the photographs are Huie's partners in the production. Hundreds of businesses participate by providing display space for photos, while granting organizations, city workers, and volunteers collaborate through donations of money, materials, and time. Other crucial collaborators are the director and staff of Public Art Saint Paul, the nonprofit arts organization that has encouraged, prodded, and cheered Huie's project from its inception.

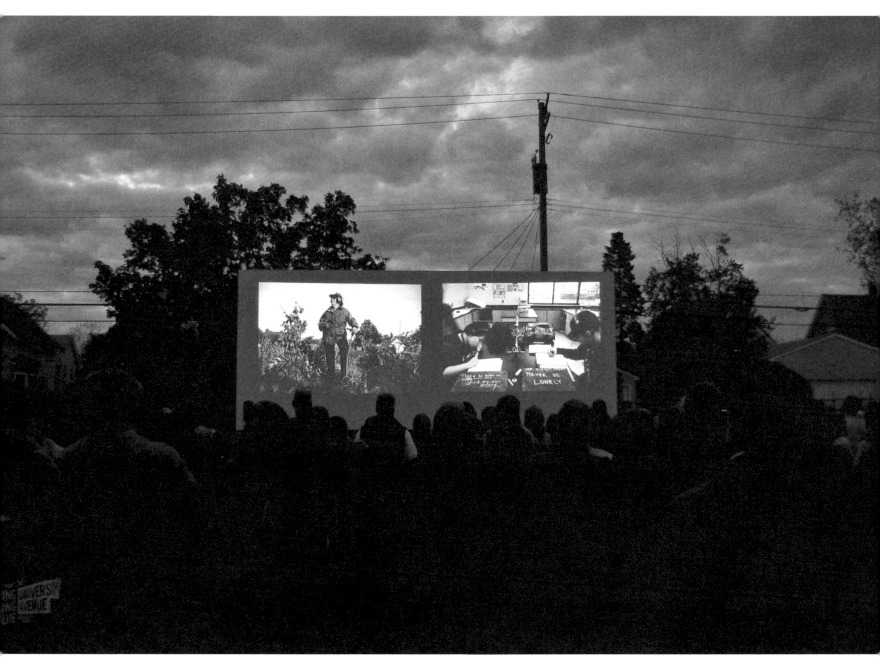

Project(ion) Site. Photo by Linda Chryssomallis

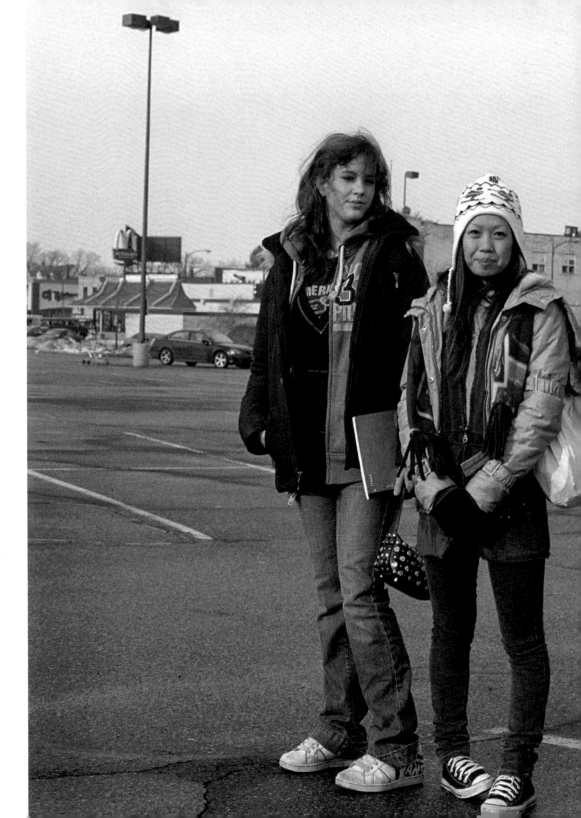

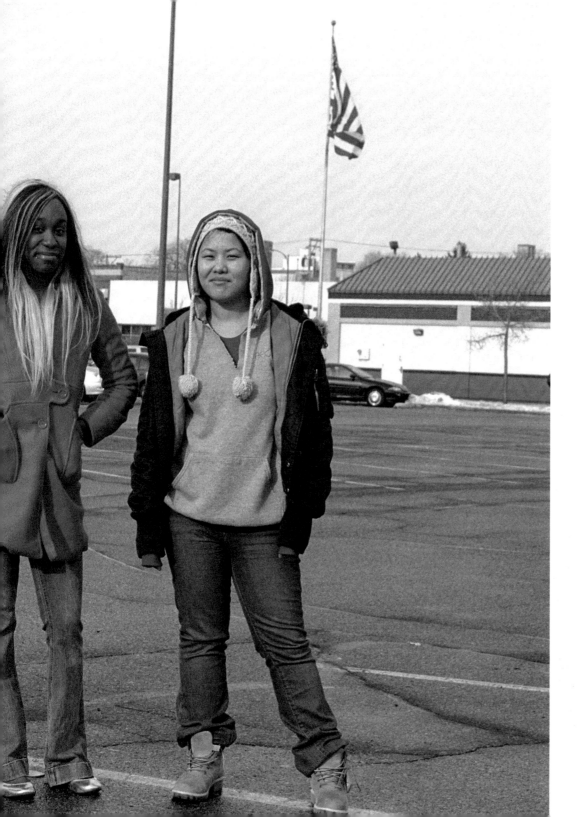

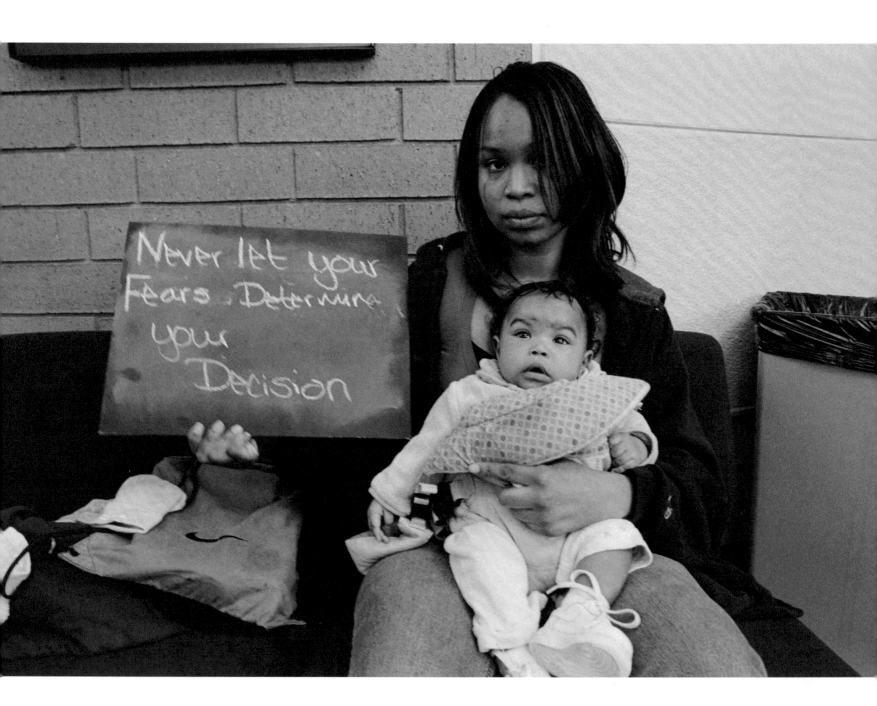

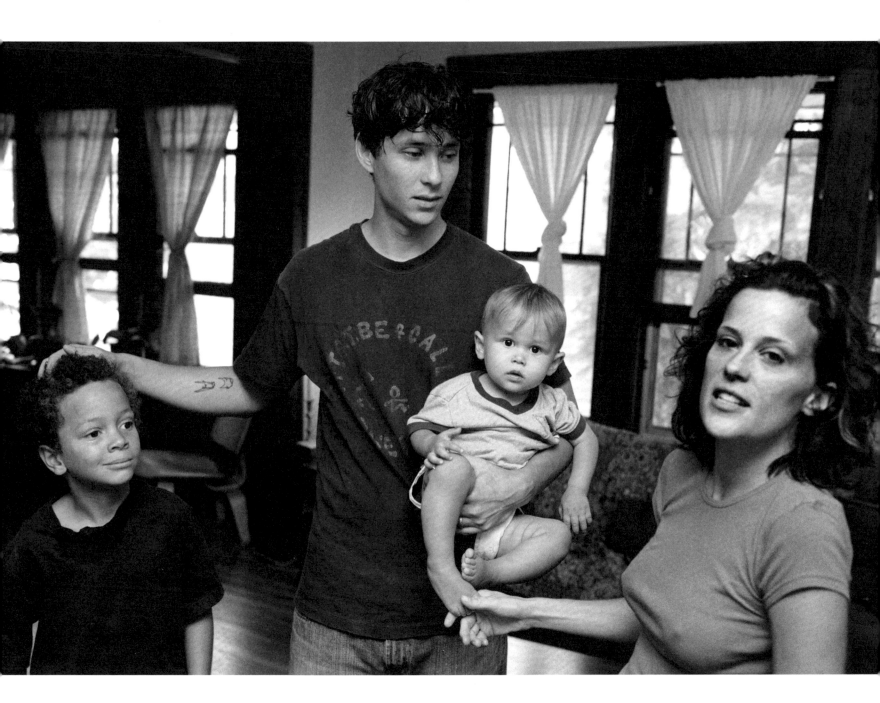

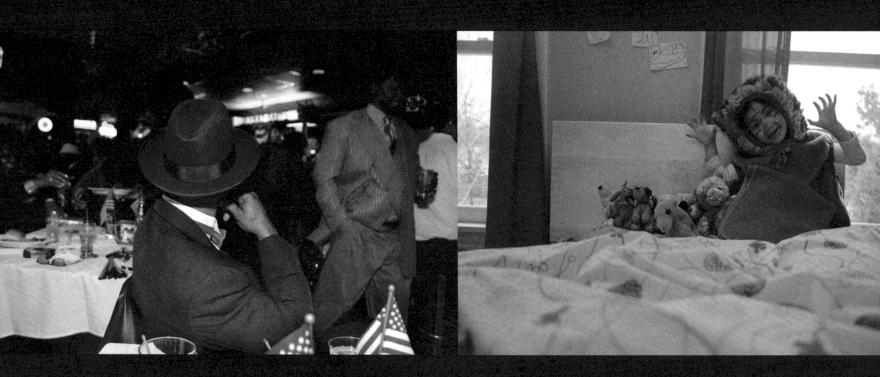

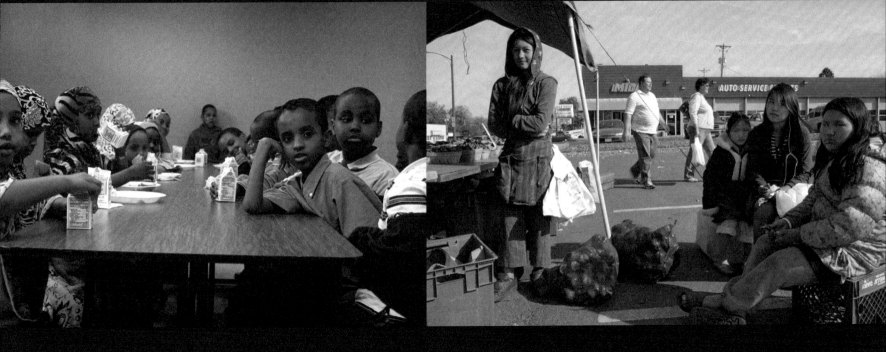

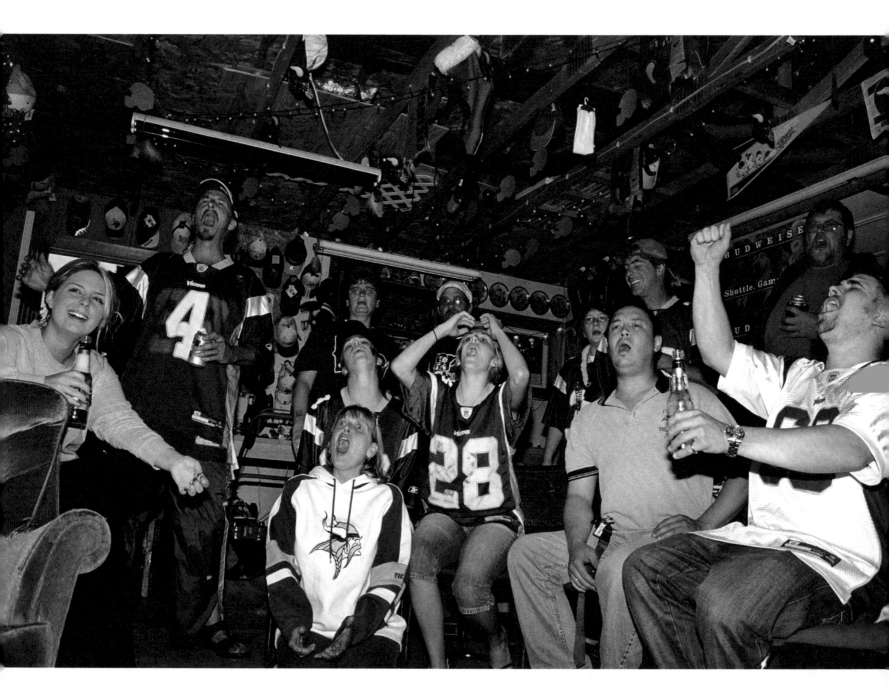

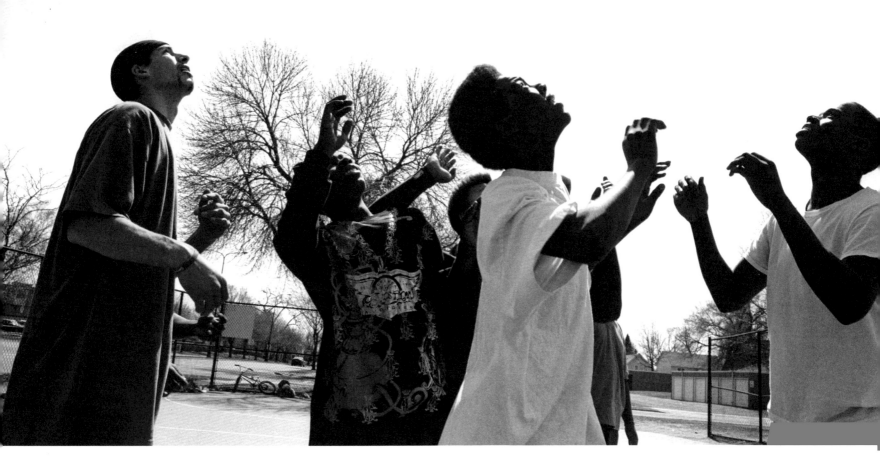

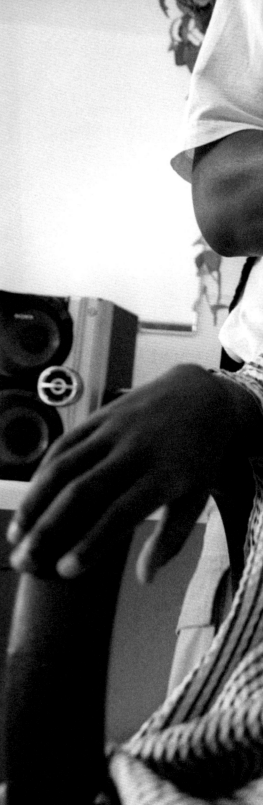

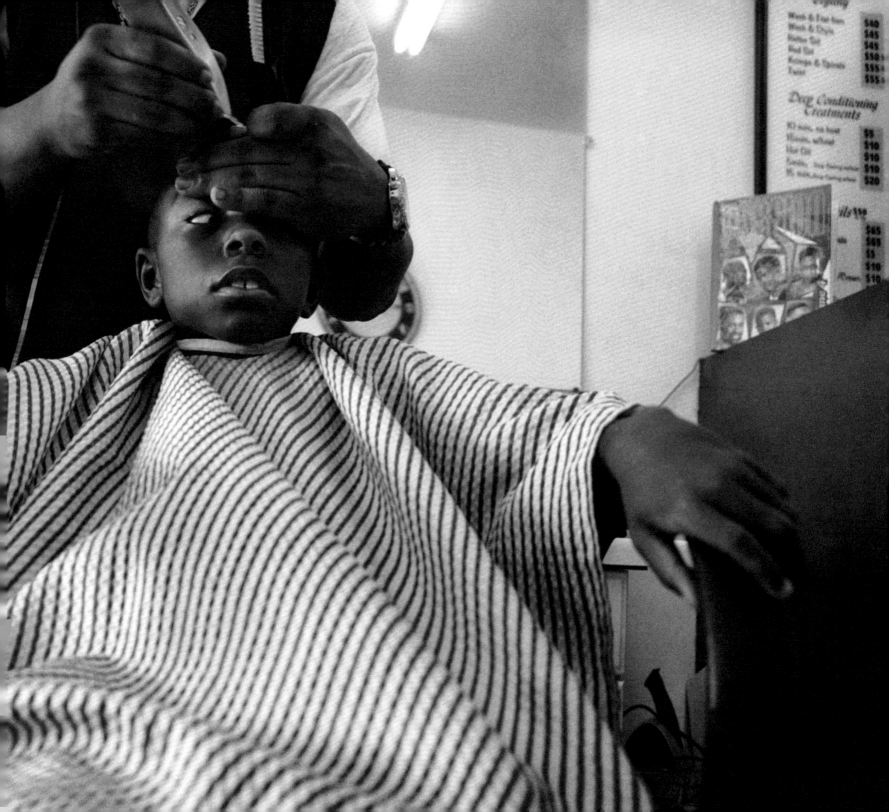

Launching *The University Avenue Project*, May 1, 2010

AS I'M WRITING THIS, we are just over one month into *The University Avenue Project*. This organic installation has five more months to go. More images will be installed as I continue to photograph.

On May 1, the day we launched the project, hundreds of people turned out during the day to view the 250 photographs placed in 80 business windows and on sides of buildings along University Avenue. Later, at twilight, 600 citizens gathered at the centerpiece of the exhibit—an outdoor slideshow of 450 photographs projected onto a drive-in movie–sized screen, set in a vacant lot midway along the Avenue.

The scene was surreal. In the midst of this often-stigmatized urban core, sandwiched between Elsa's House of Sleep, Fantasy Gifts, and the Town House Bar (Saint Paul's oldest GLBT bar), were three towers of metal shipping containers—stacked like mammoth Legos—from which illuminated images and music were emitted, beckoning to passersby. It was powerful to be part of such a rapt, communal experience in an unexpected place.

On every subsequent night, whether drawn by media attention, word of mouth, the spectacle of public art, or just happenstance, there have been viewers, sometimes up to 40 people. During our first cabaret of live performances of music and spoken word, the crowd neared 400. Even when the temperature has been in the 50s and it's been drizzly, handfuls of people have shown up. Many stay for the entire 90-minute show to see all 450 photos randomly paired side by side on a 40-foot screen, one changing every 15 seconds, the other every 30 seconds.

Sometimes the space feels like a town square or Times Square. A street preacher gave an impromptu sermon. A man who said he was homeless, sporting a broken nose from a fight the night before, put a dollar in the donation box. One woman left in tears. A group of teens hawking CDs of their music walked by and asked what was going on. When it was explained, one of them remembered being photographed by me. At that moment, as though on cue, his photo appeared on the screen as he yelled, "That's me!"

Installation view

Installation view

People have arrived on bikes, some bringing portable lawn chairs and snacks. One made drawings of animals that he gave away to people. Some have come regularly and many have made repeat visits. First-time viewers usually sit in silence to absorb the experience.

One guy who cuts hair down the street came a few times and told a long hilarious story about being pulled over by the police while driving a car wearing a Spider-Man suit. I wasn't sure whether to believe him until he pulled out his iPhone and showed us a photo he took of himself as Spidey with the police posing behind him.

Another, who lives one block away, said he had heard something was going on but didn't really know what it was. He at first watched tentatively from the sidewalk but then came inside the chain-link enclosure and stayed a while. He told me that his two nieces who live in South Minneapolis won't visit him because they are afraid of the area. He would come back with them, he promised, so they could see what the neighborhood is really like.

One visitor has come often enough that Abe Gleeson, the Public Art Saint Paul employee who takes care of the site, has given him odd jobs. The young man told Abe that he's been homeless and addicted to meth, that he knows all the street kids on the Avenue. In a comment book at the site, he wrote: "I wish tears could talk. When I'm here I feel like I'm on a Mountain Stage, and

the World, if it could talk, would say, 'This here, what you guys have going on, is literally what it's all about.' Thanx 2 all involved. This is HUGE."

A painter friend of mine, born and raised in Germany but now living in the Twin Cities, said she feels like she lives in a different city from the one in my photographs. "It's as though you're mapping an uncharted territory," she said, "like the ocean. We seem to live on islands that are like ghettoized communities, driving from place to place. A lot of what surrounds us escapes us."

A week after the launch, I was walking down the Avenue when a woman recognized me from coverage of the photographs. She grabbed me and hugged me like a long-lost friend. It turned out she was related to Gordon Parks, the great African-American photographer who grew up in Saint Paul. After our hug, she kept thanking me. As she walked away, I heard her say, "People don't know about us. They have no idea."

Aside from people's comments, how do you really gauge, qualify, or quantify the impacts and meanings of this kind of exhibit? I'm not really sure. In a way, this exhibition is a social experiment, or a study in hyperreality. What is the *real* real?

On the Avenue there already exists a photographic din of marketing realities. A recent study shows that the average

person in a major metropolitan area "sees" 20,000 photographs in a day. But how many of those images reflect the everyday realities of the people looking at them?

The hundreds of images in *The University Avenue Project* attempt to reveal the realities of people who live and work in this diverse urban area. Add to this Chinese box of realities all the spectators from outside the area who descend upon the Avenue to experience the exhibit, commingling with people who are from the Avenue (and in the photos). Layer that with all of the media attention about the exhibit, with their particular spins about what this all means, and you have a virtual photographic Tower of Babel, all competing to represent "us."

People often ask me why I do what I do. Sometimes I say, "What I want to show is not only what is ignored, but also what is in plain sight and remains invisible." Or more recently I've answered the question with, "I am creating a new iconography because the perceptions of who we are as 'real' Minnesotans or Americans haven't caught up to the realities."

But these and other answers I give seem slippery and somewhat self-serving. I mean, how do any of us really know all the reasons for what we do? In the end, I don't think the *whys* are all that important.

It's the doing that counts.

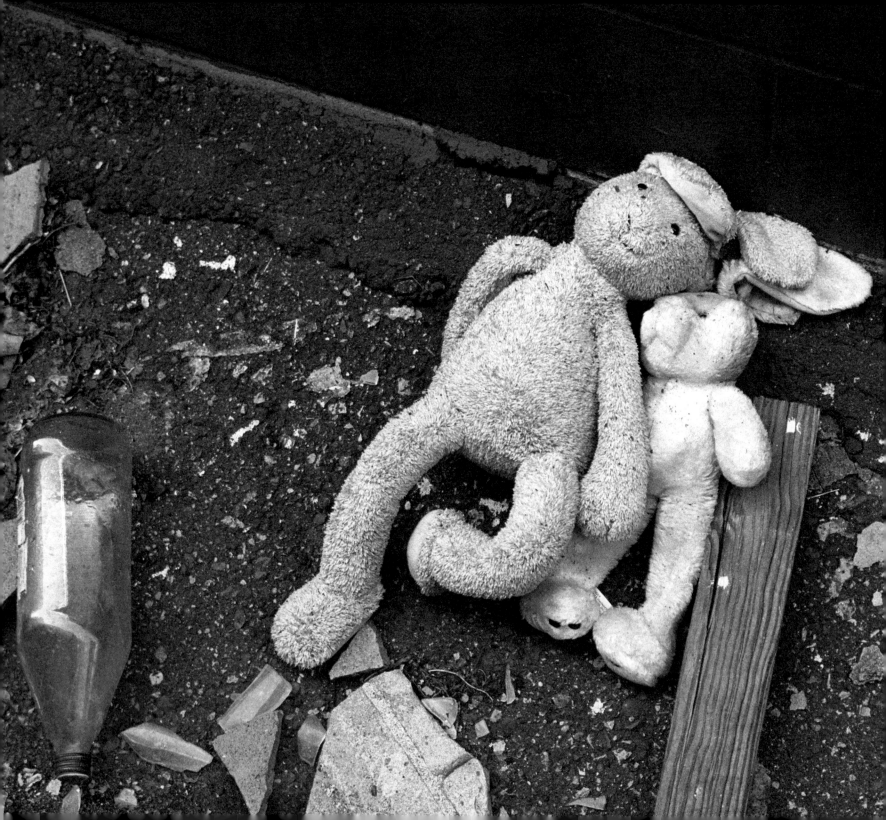

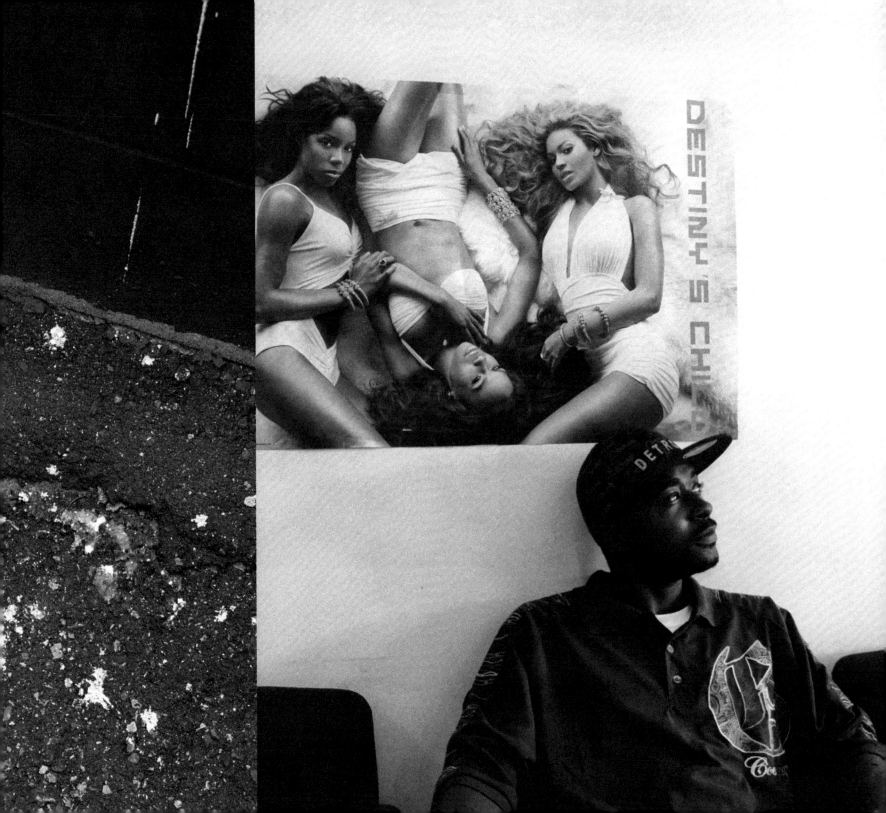

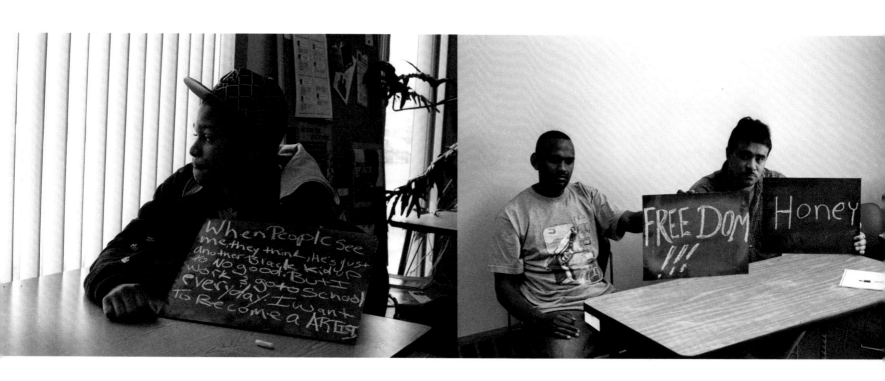

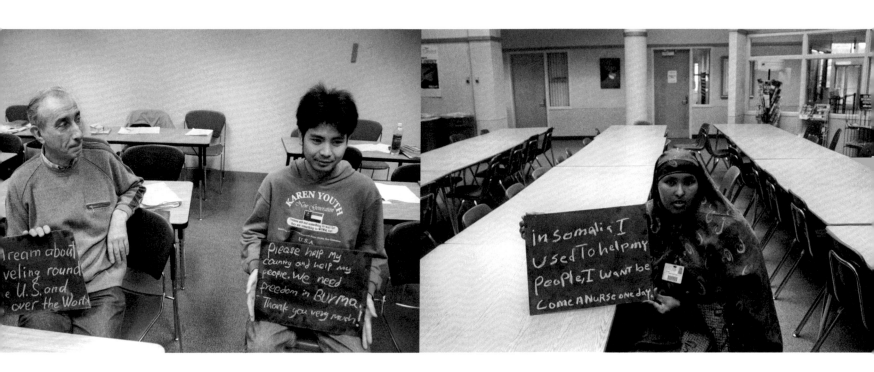

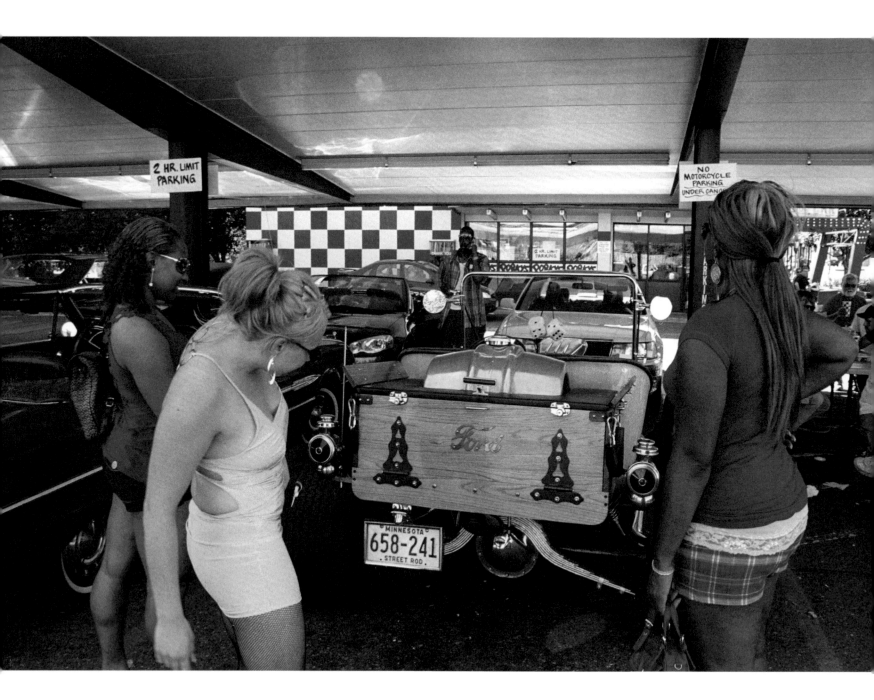

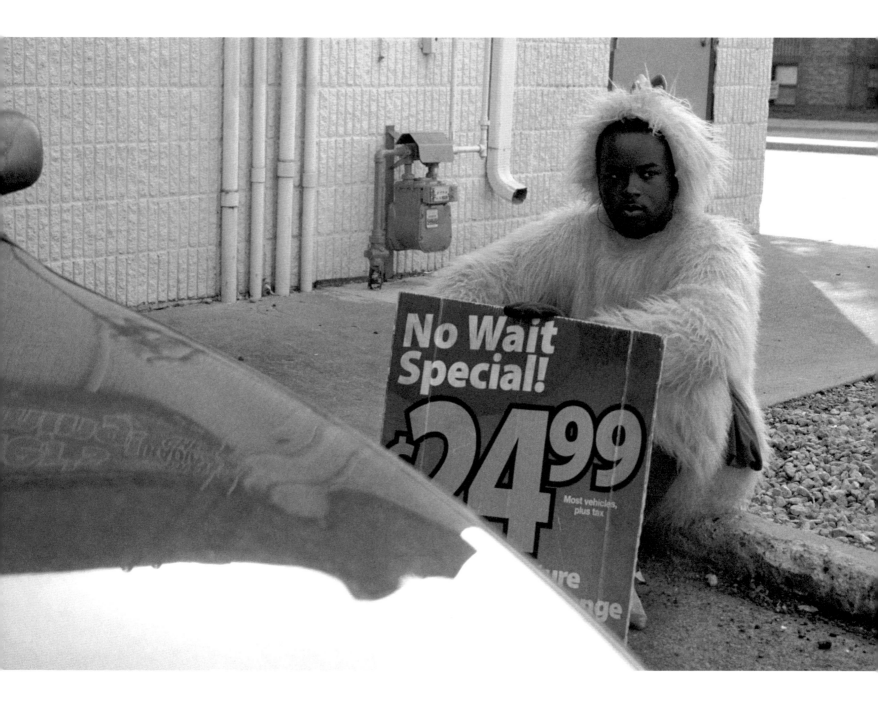

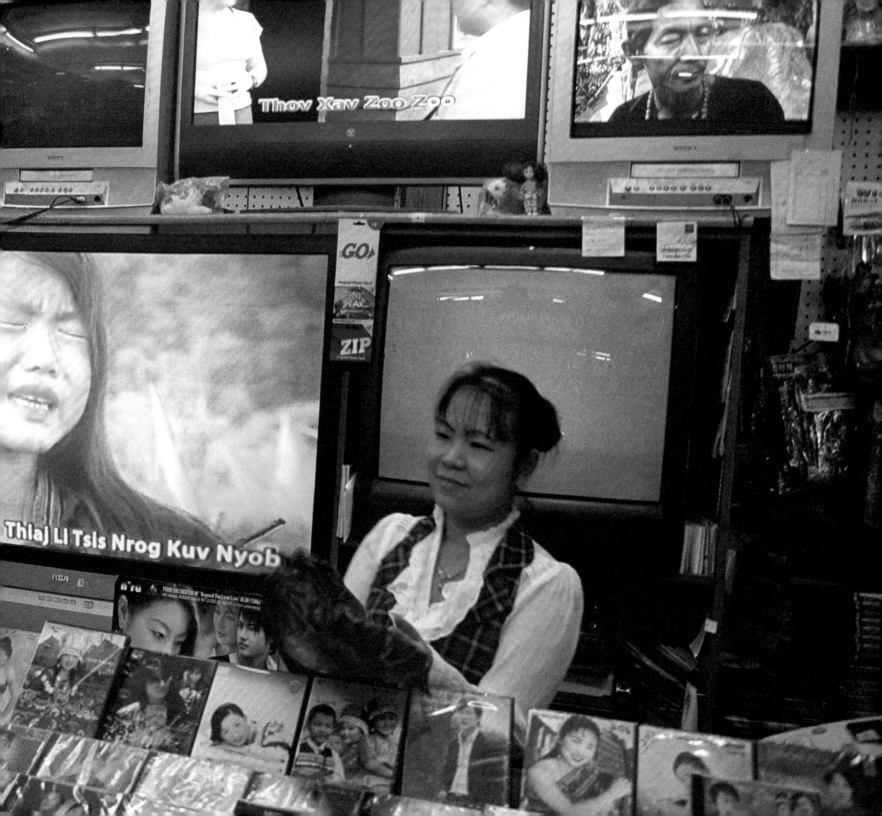

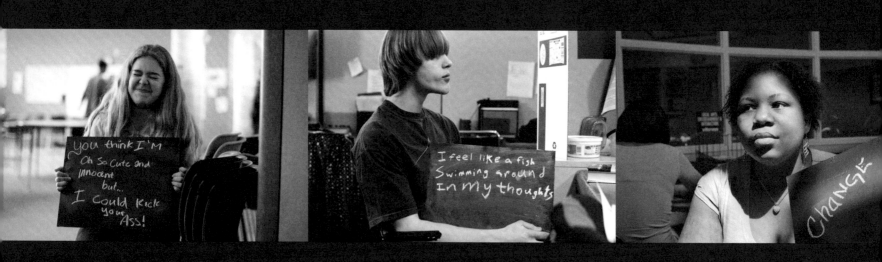

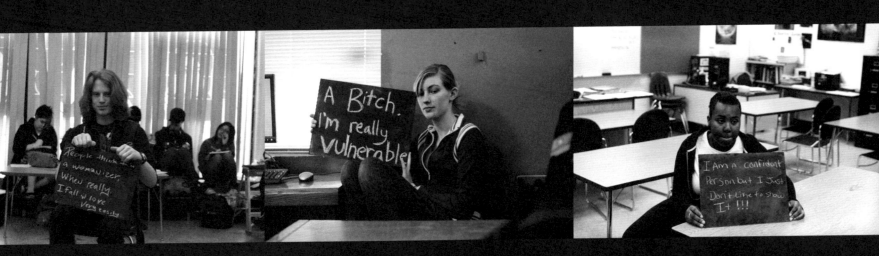

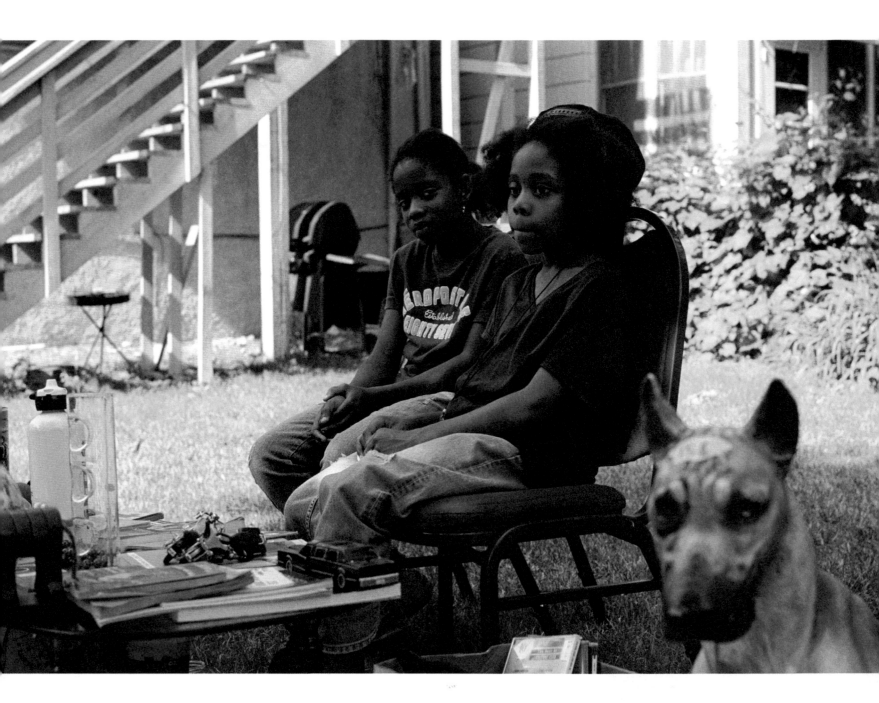

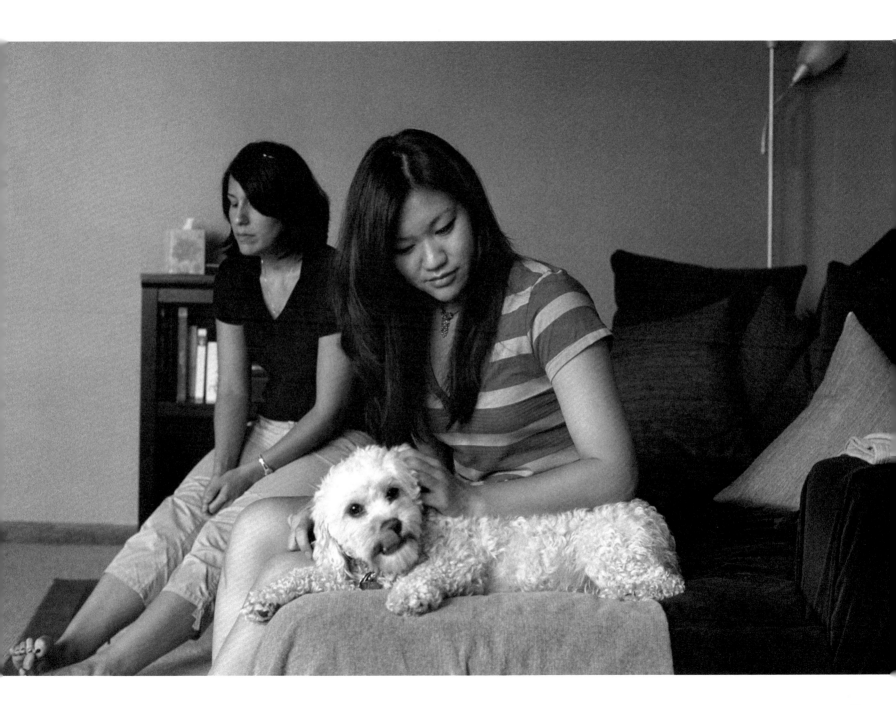

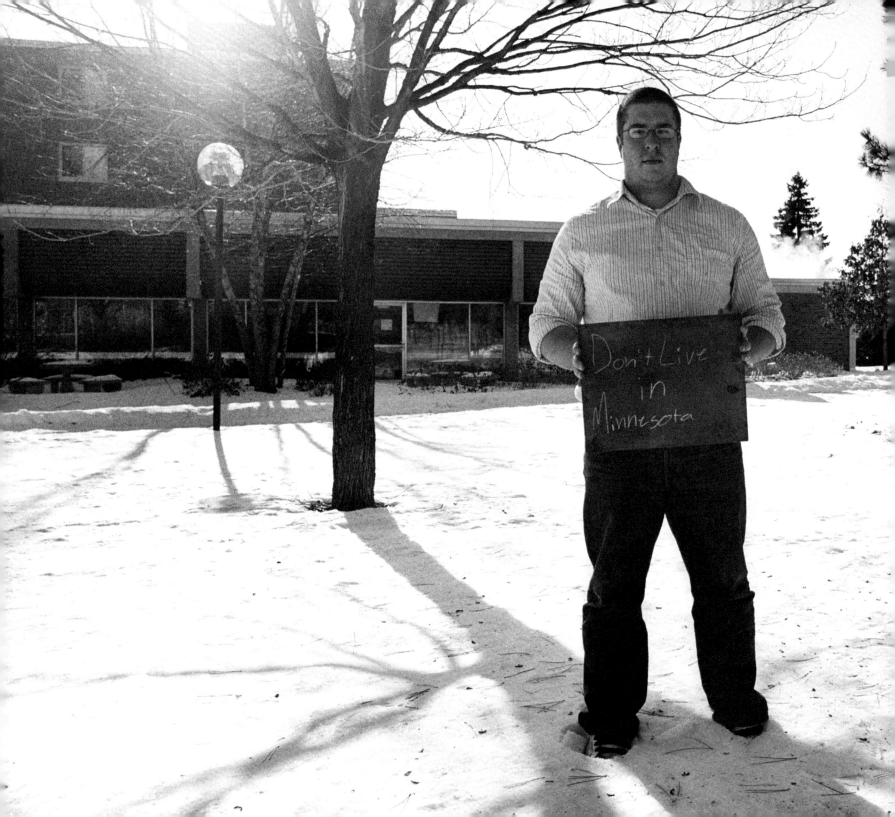

SO MUCH SADNESS.
SO MUCH DESPAIR.
AND SO MUCH HOP
ALL IN ONE PLACE.
—ANONYMOUS CO

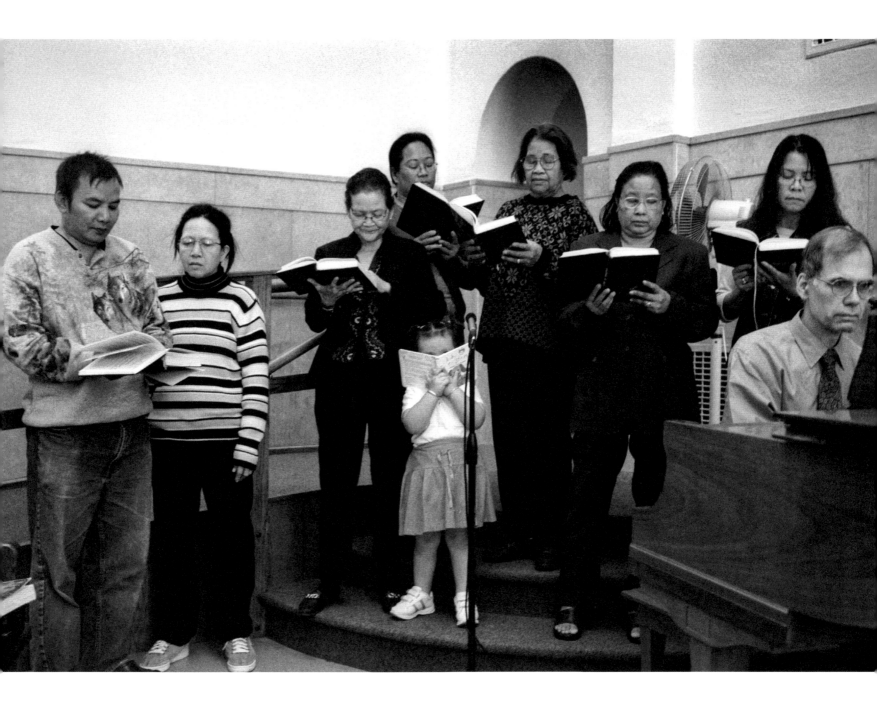

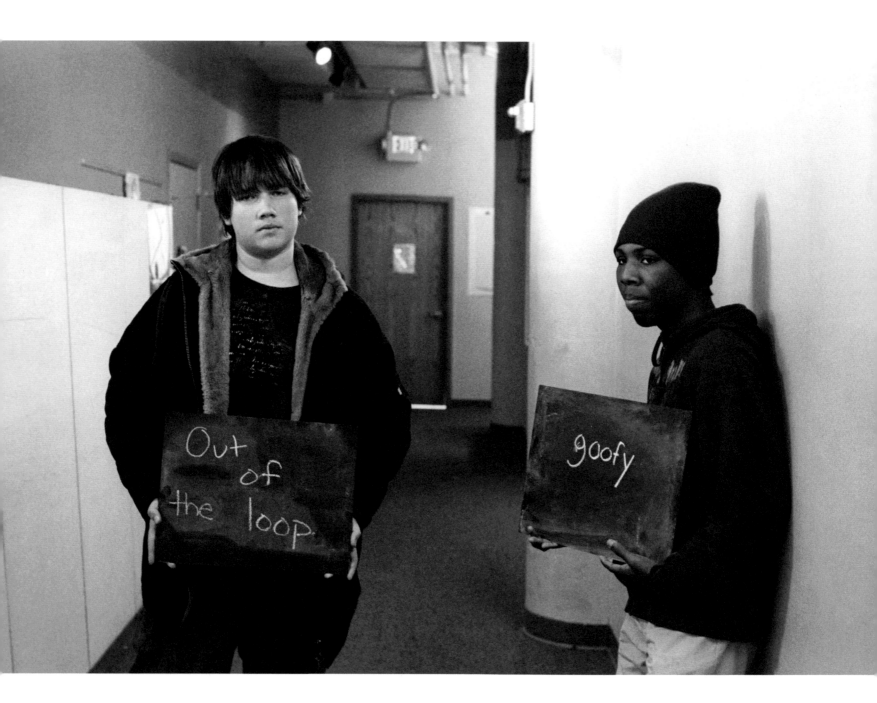

Photographing the Other

SOMETIMES WHEN PHOTOGRAPHING, I ask people if they will approach someone in their neighborhood or school whom they don't know. I want them to ask the other person about being photographed together. It's an idea that I've been carrying around for several years—photographing people who are somewhat familiar with each other but for whatever reason don't really know each other; people who sit in different parts of the cafeteria, so to speak.

For instance, in the photograph on page 44 taken at Avalon, a charter school of fewer than two hundred students, I asked the boy on the left to pick another student at the school whom he considered outside his immediate social group. He picked the boy on the right. I asked both of them a series of questions:

What are you?
How do you think others see you? What don't they see?
What advice would you give to a stranger?
What is your favorite word?
Describe an incident that changed you.
How have you been affected by race?

Next, I gave them each a piece of chalk and a small chalkboard I made. Finally, I asked the boys to pick one of the other person's answers to write in chalk. The chalkboards they cradle in their hands hold one of their answers.

At Hamline University, just north of University Avenue, the process was slightly different. The students in these photos (on pages 46 and 47) chose others in the same class whom they didn't know well. They asked each other the same series of questions, this time in private without my interaction. I sat down with each pair afterward and we all discussed their answers. The three of us then decided which answer seemed the most interesting and revealing to write on the chalkboards.

People think I'm Christian, heterosexual, and rich. I'm none of those things.

I want them to see me as a normal person. Someone who could be their daughter, mother, wife, a human being.

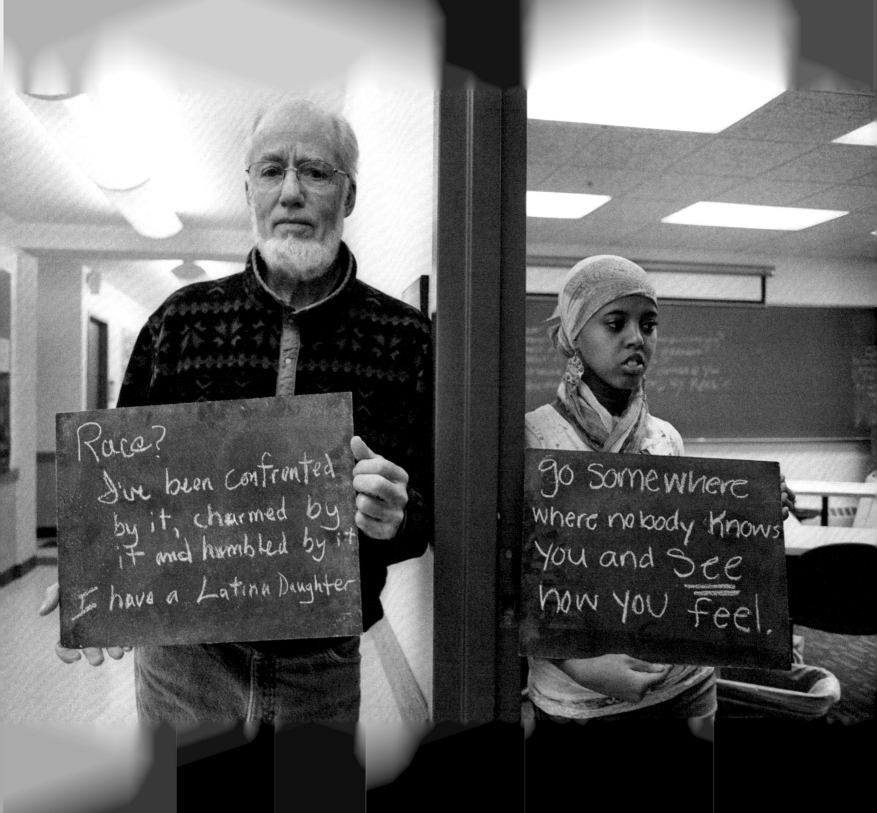

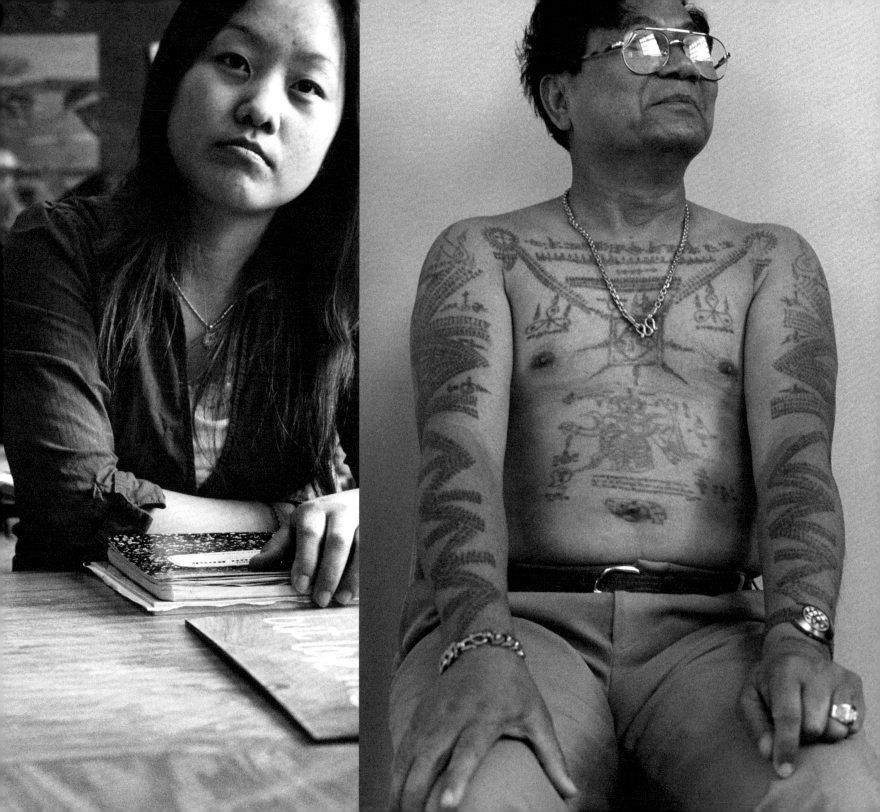

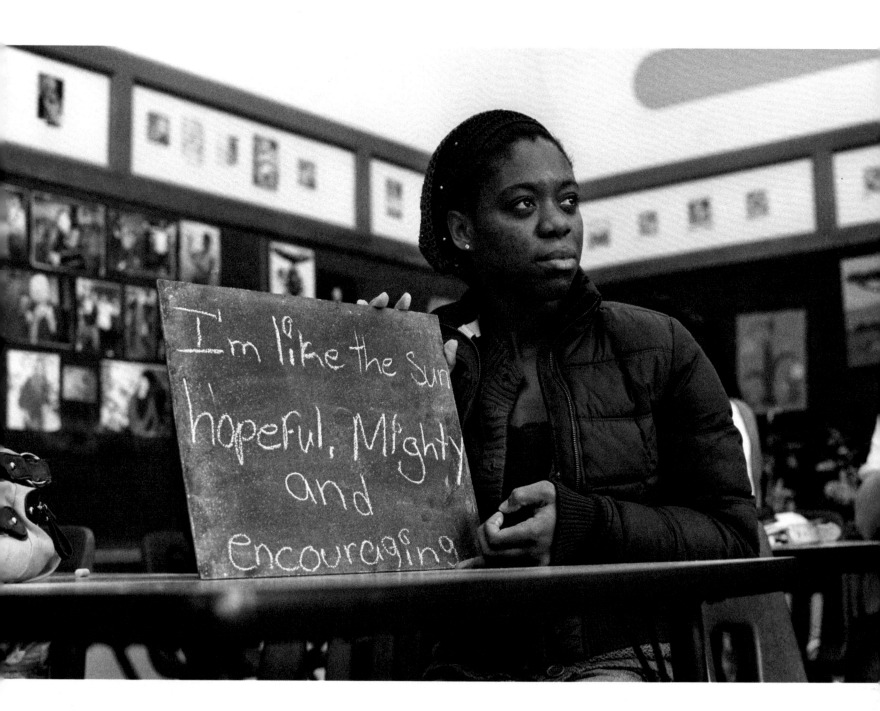

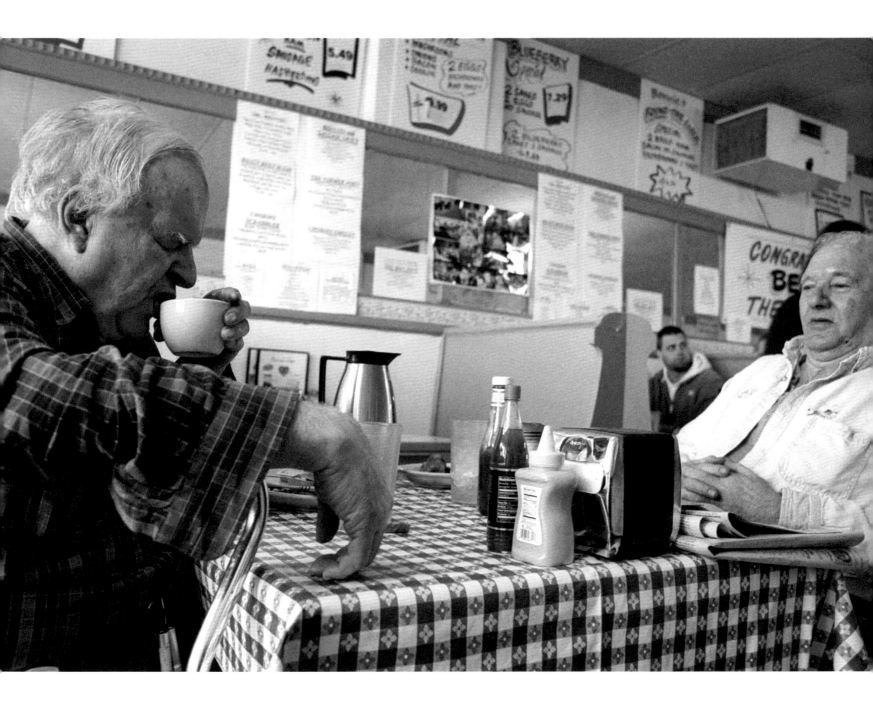

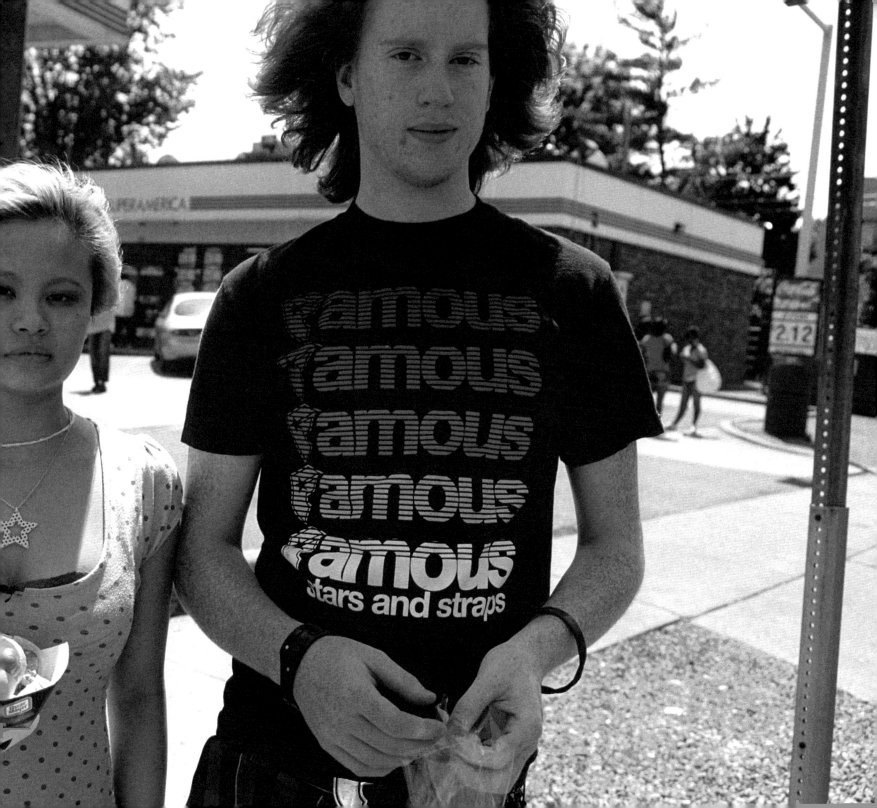

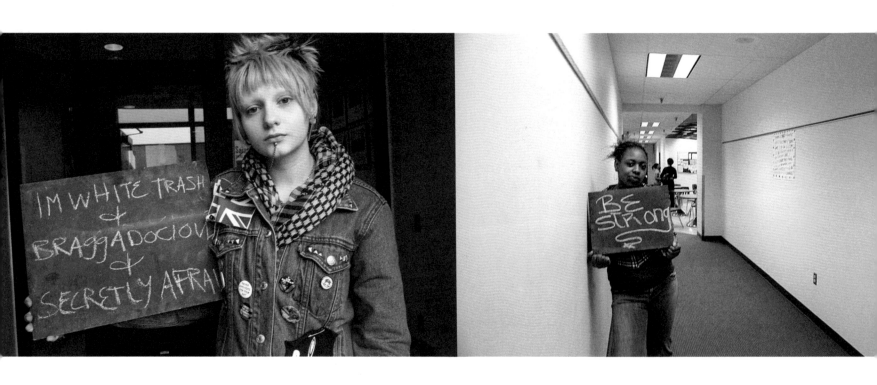

54

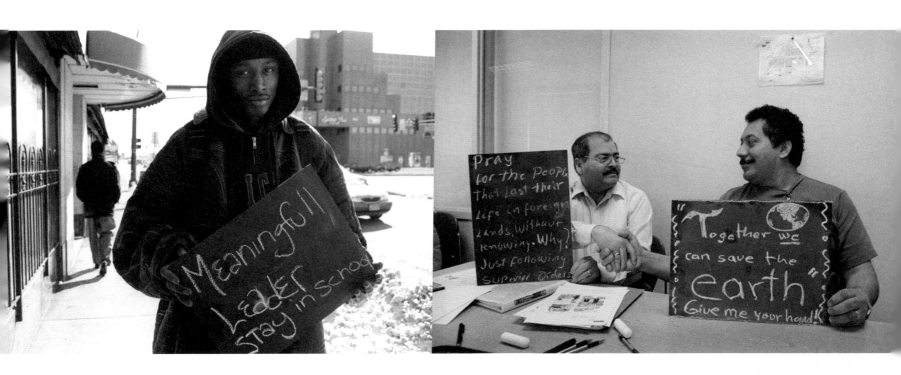

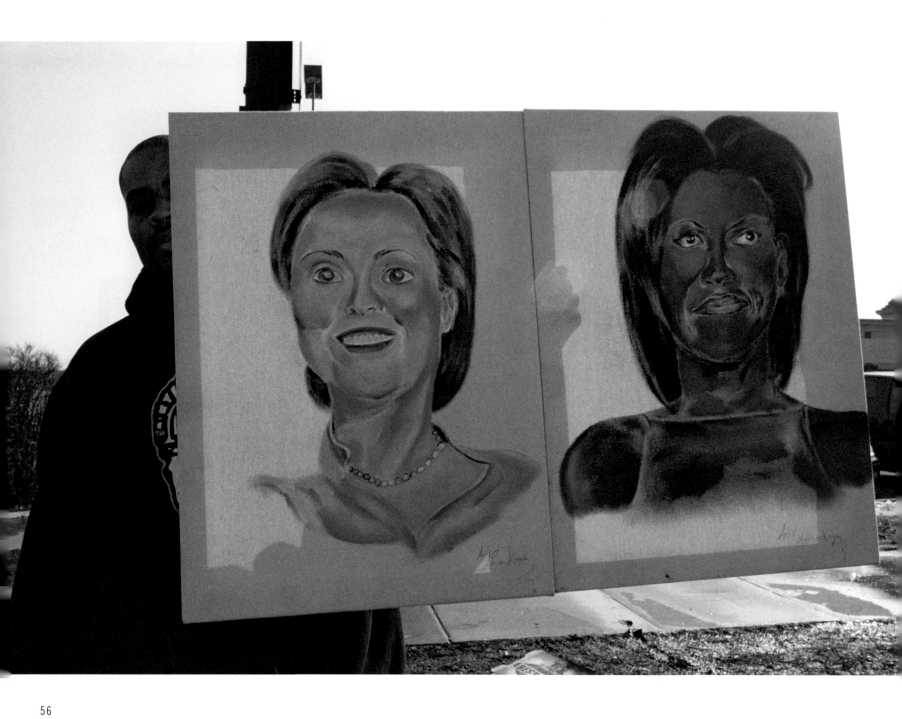

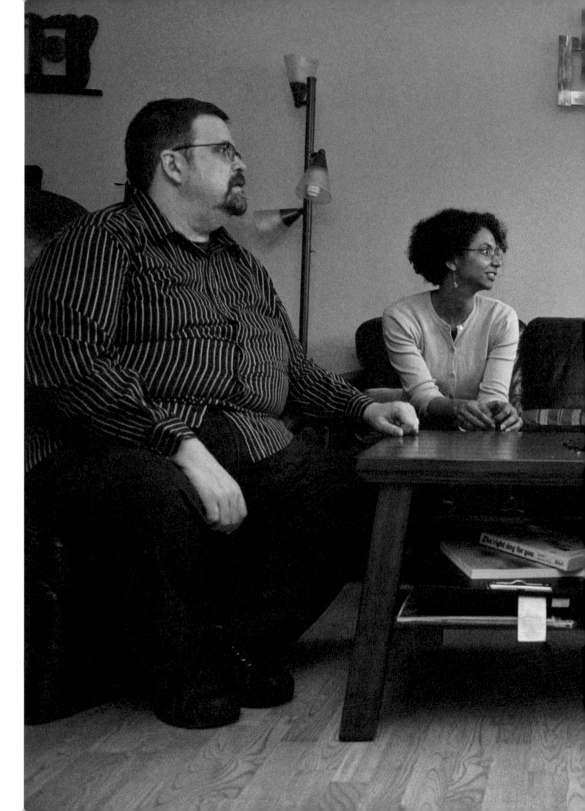

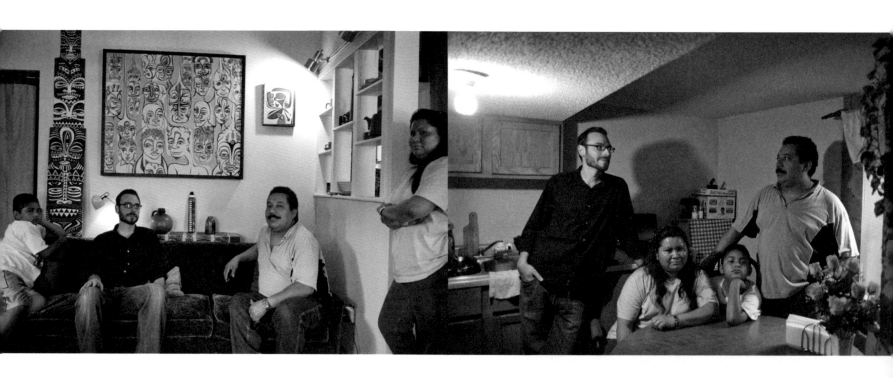

The Other at Home

I CARRIED THE IDEA OF PHOTOGRAPHING the Other a bit further in a series of images taken inside people's homes. At Emerald Gardens, a recently developed condominium complex of several buildings near the Minneapolis–Saint Paul border, I was photographing during National Night Out, an event designed to raise community awareness. Emerald Gardens is a new Saint Paul community, built on what was once an industrial area. On the night I was there, about sixty residents of the condominium complex were hanging out in a common plaza, barbecuing and getting to know each other.

I approached Rob and Patricia, a married couple. They had lived at Emerald Gardens for three years but didn't know any of their neighbors. Ironically, they did know the names of their neighbors' dogs because of walks in the neighborhood with their own dog.

After talking for a short time, I asked them to approach another condominium resident—someone they didn't know—so that I could photograph them all together. Rob immediately walked toward Rey and Rocky, a couple he couldn't recall having seen before. He later said

he picked them because they "had the right energy, a combination of confidence and calm to make you want to know them better." Rocky (the wife) said later that it was a treat to be singled out. "It makes you think, is there something about us as a couple that stood out? We were not the only Asian-Americans in the group, so we must have been wearing the right perfume that day."

Rey and Rocky decided that they should have Rob and Patricia over for lunch the following week, with me there to photograph all of them. I took the photograph as soon as Rob and Patricia entered Rey and Rocky's condo, before they became too familiar with each other. Then I sat down for lunch with all of them. In the photograph on pages 58-59, Rey and Rocky are on the right, while Rob and Patricia are on the left.

Of the experience, Rob wrote: "We'd never met them anywhere in the neighborhood. We didn't even know what building they lived in. But it seemed like the tie we all shared was cultural globalization. Rocky and Rey are from the Philippines, although they've globally hip-hopped around the planet. Patricia is from São Paulo,

Brazil, and I attended university in London. We all share melting pot experiences OUTSIDE our neighborhood and community."

I continued the experiment of photographing neighbors—and strangers—together in neighborhoods along the Avenue. The photographs on page 60 are taken at the other end of University Avenue from Emerald Gardens, in an old, established neighborhood called Frogtown that borders the State Capitol.

The man in the black shirt is a music teacher I met at Creative Arts High School. He lives alone in a house he owns in Frogtown. For this photograph, he went across the street and knocked on the door of a basement rental apartment. There, he met a family that had emigrated from Mexico. I photographed the teacher and the family in each other's homes. Coincidentally, I discovered I had already photographed the father of the family at the Hubbs Center for Lifelong Learning (in the image on page 55) the year before.

People Say I'm an Uh-oh Oreo (White girl that acts black) because I'm not your typical "White Girl"

Because I use Big words people call me an Oreo, But yet I have always lived in the HOOD!

I am a advocater for human rights.

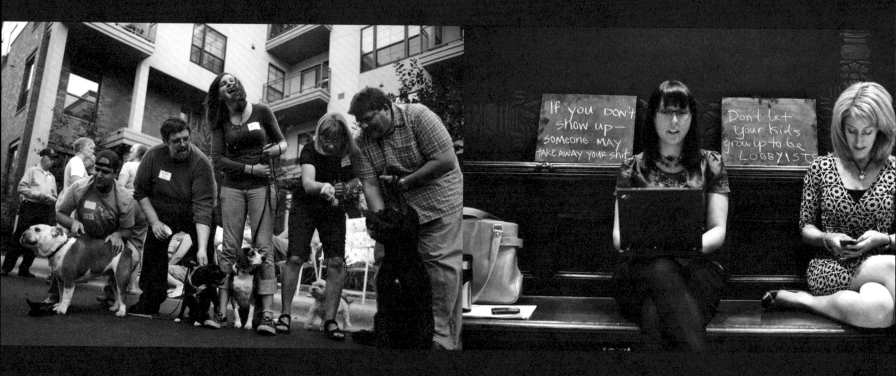

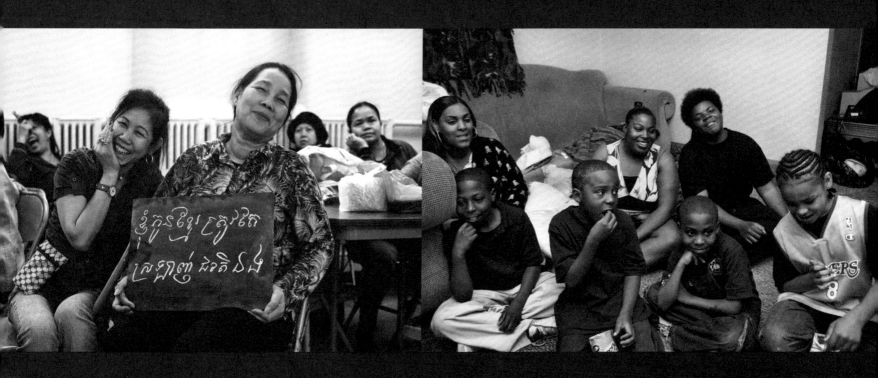

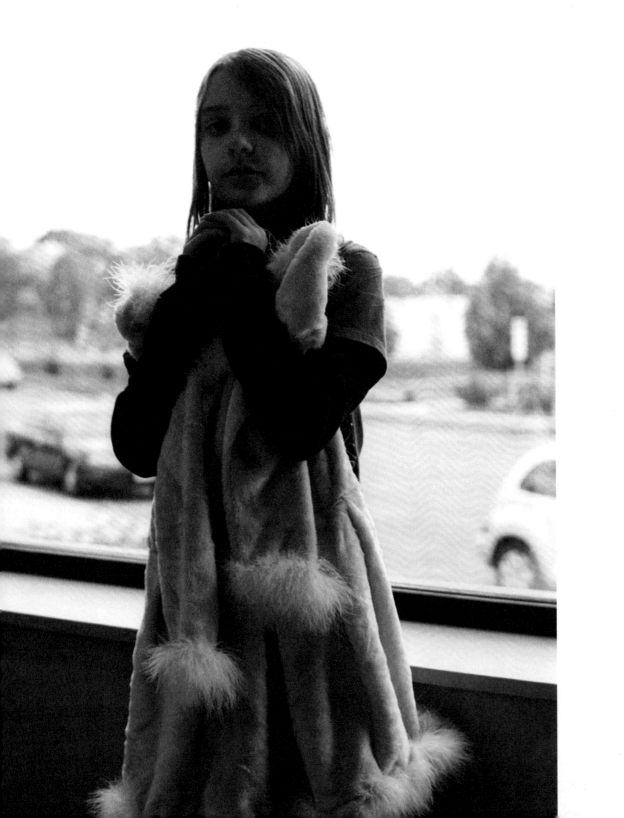

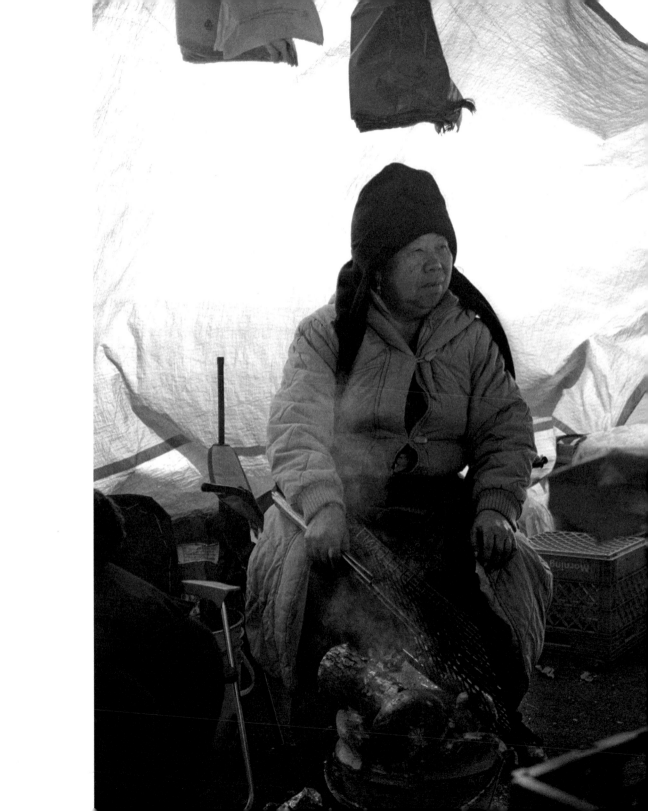

I would advise a stranger who is new to the U.S. to wear more layer of clothes.

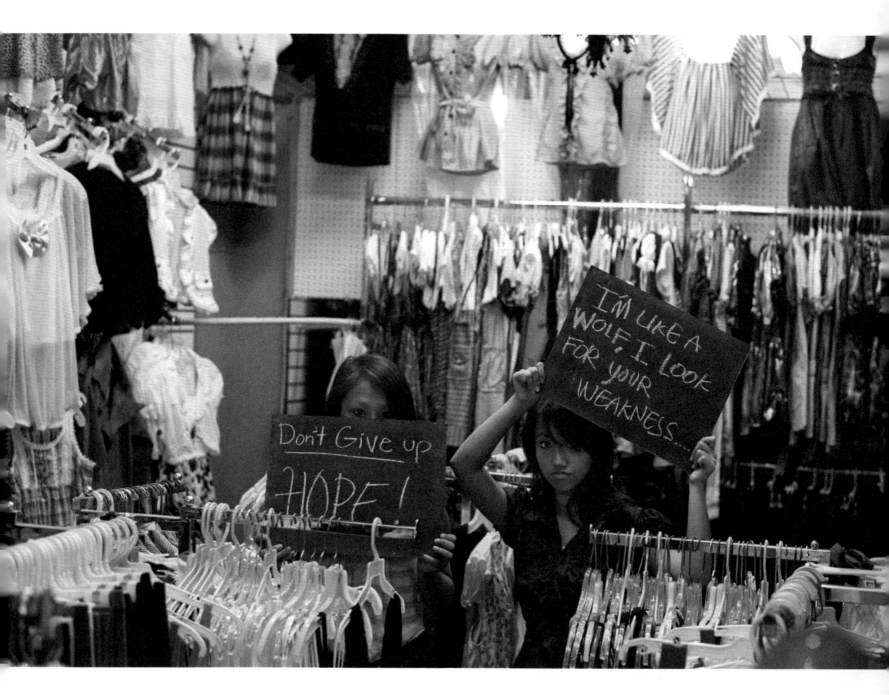

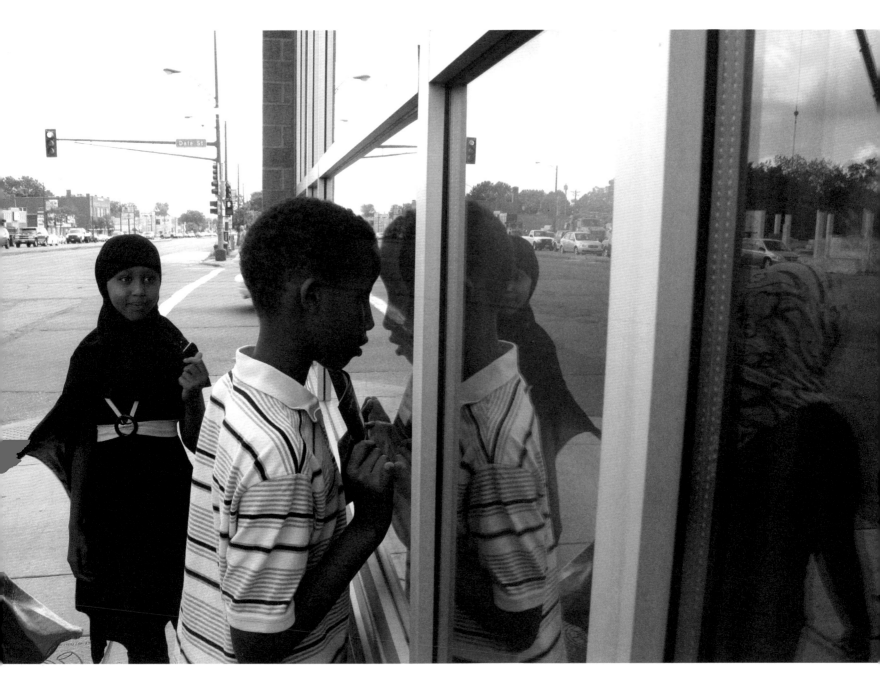

Installation view

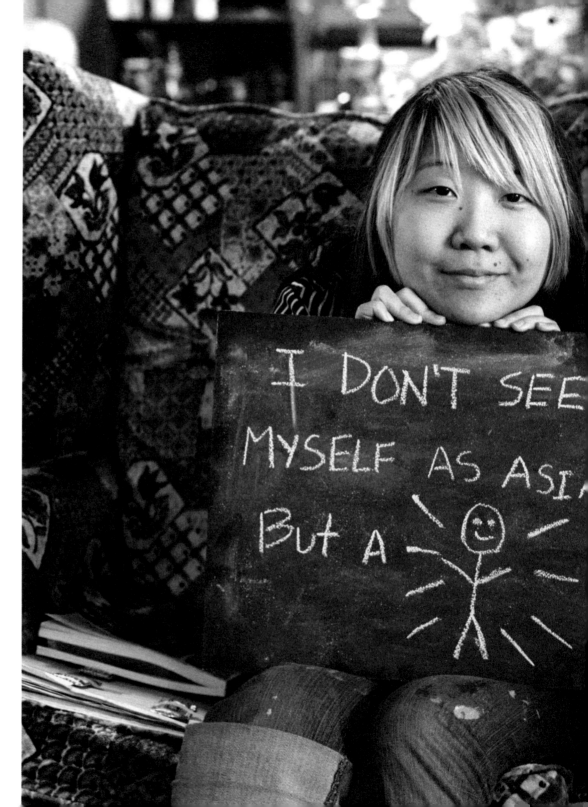

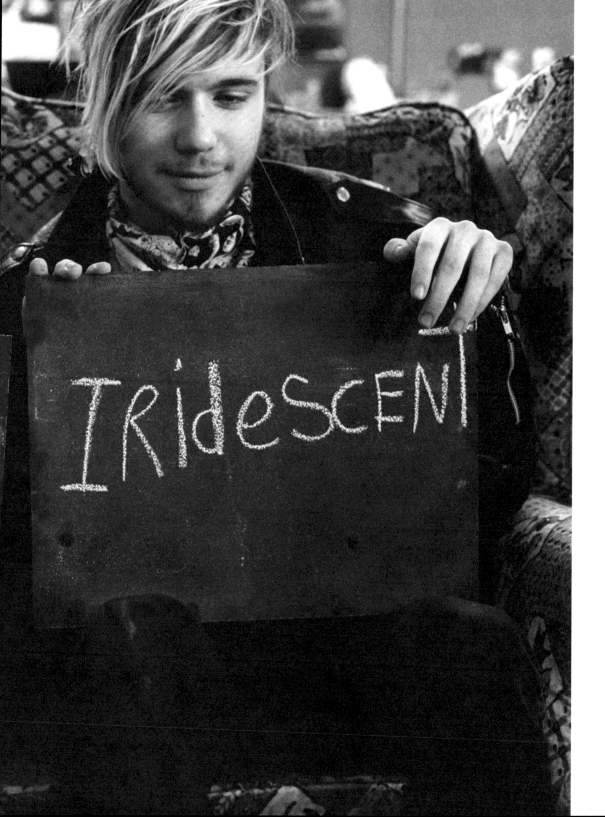

"IT REMINDED ME HOW MUCH **I DON'T SEE IN MY DAY-TO-DAY LIFE**. SO THANKS FOR REMIND-ING ME TO SEE MORE."
—ANONYMOUS COMMENT

Installation view

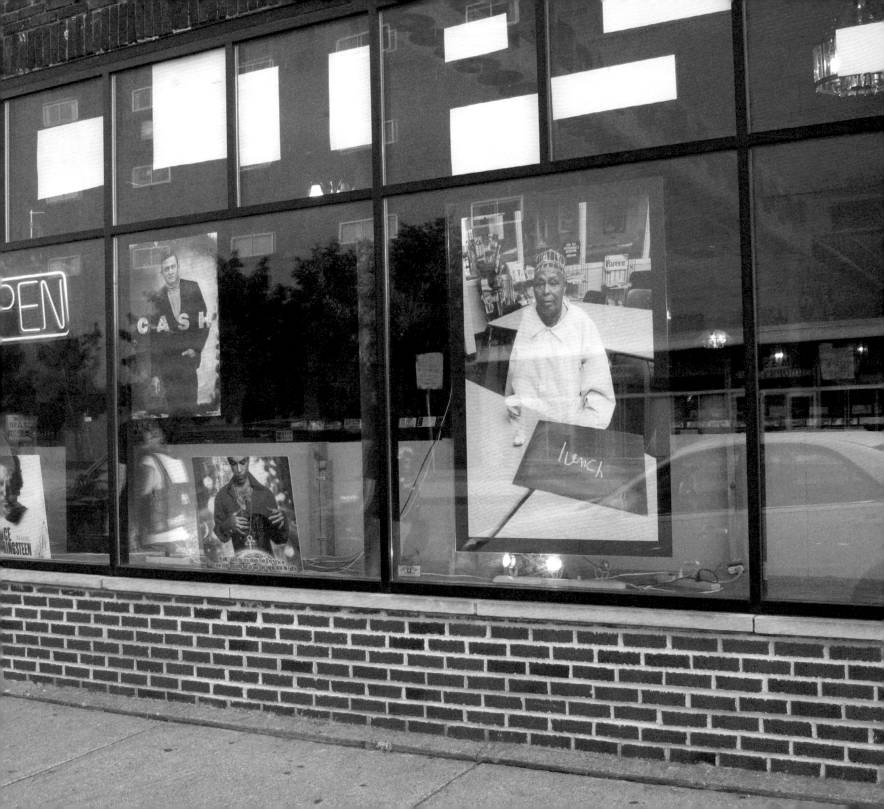

Real Photographs

I'VE GIVEN HUNDREDS OF PRESENTATIONS and work-shops to audiences of all kinds over the last fifteen years, to kindergarten classes and universities, law schools and prisons, nonprofits and corporations. Apart from subsidizing my income, I've found that the dialogues I have with participants affect how and what I photograph. These conversations also impact my pre-sentations—to the point that the act of photographing and the act of showing people what I've photographed are creatively intertwined.

I was giving a presentation to sixth-graders at a subur-ban school just outside Saint Paul a couple of months ago when the students got into an emotional debate.

One boy announced, "I really like your pictures."

"That's great," I said. "But what do you like about them?"

"Well, they're real."

"Don't you ever see photographs that are real?" I asked.

"No," he said.

The teacher then asked the students to pick a photograph that they didn't like or that made them feel uncomfort-able. One boy chose a chalkboard photo. "I don't like what that person wrote," he told us. "They're telling you their secrets, and people can take advantage of them."

Another boy agreed. "Yeah. People will hurt you if you show them your vulnerabilities."

There were lots of nods of agreement, but one girl raised her hand. "I think that if you let people know what you're really like," she said, "it can make you stronger."

I then asked, "What would happen if everyone did this, if everyone showed their vulnerabilities?"

"Well, then" said the first boy, "the world would be a different place."

Wing facilitates the chalkboard process at the Project(ion) Site.

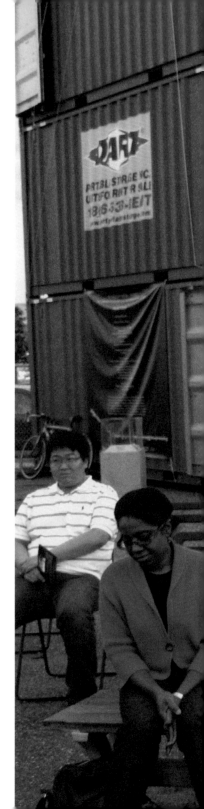

សាសនាសុទ្ធតែល្អ ៗ ៥ ៈ ៗ
ប៉ុន្តែ សង្គមមនុស្សទេ
ដែលអាក្រក់ ។
ALL RELIGIONS ARE GOOD,
BUT A HUMAN IS BAD.

81

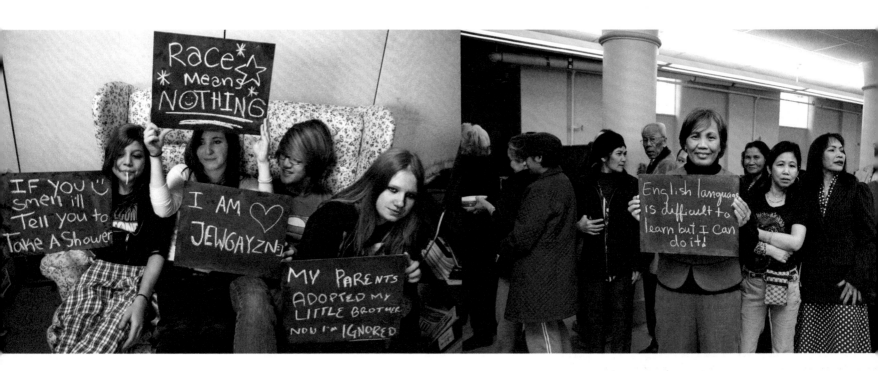

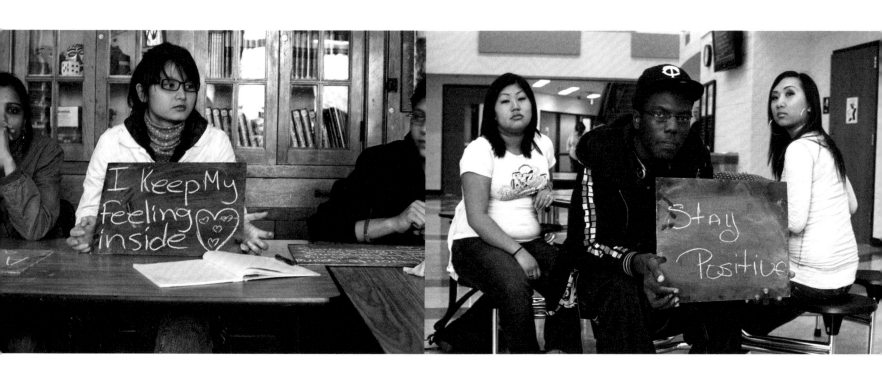

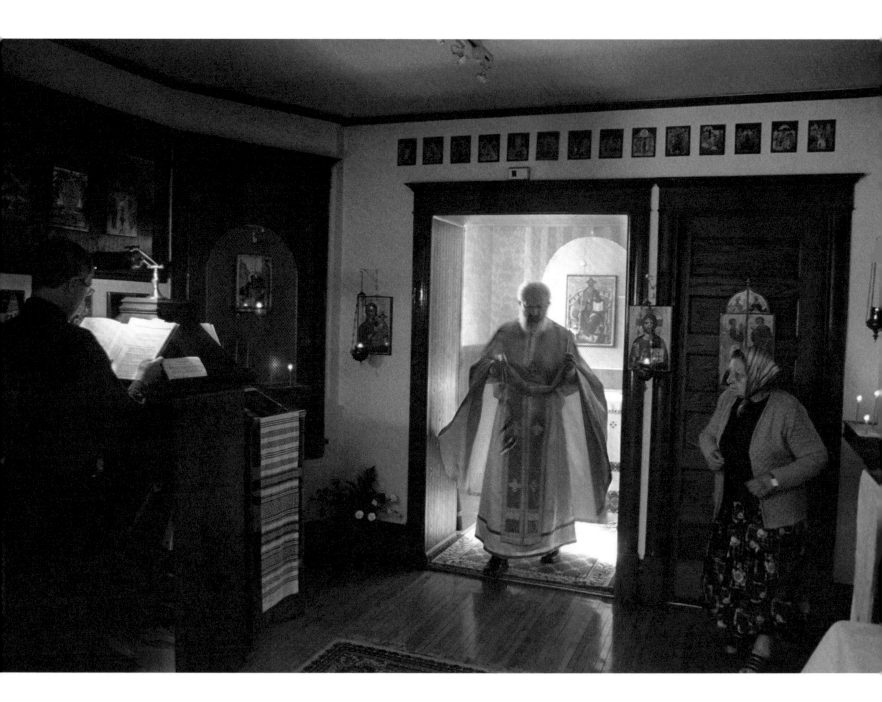

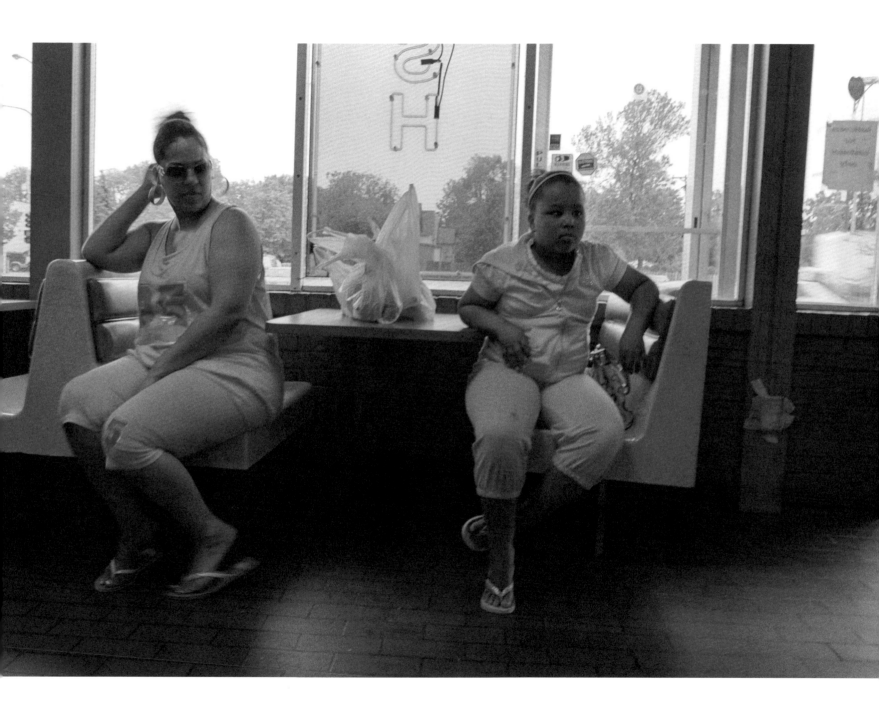

86

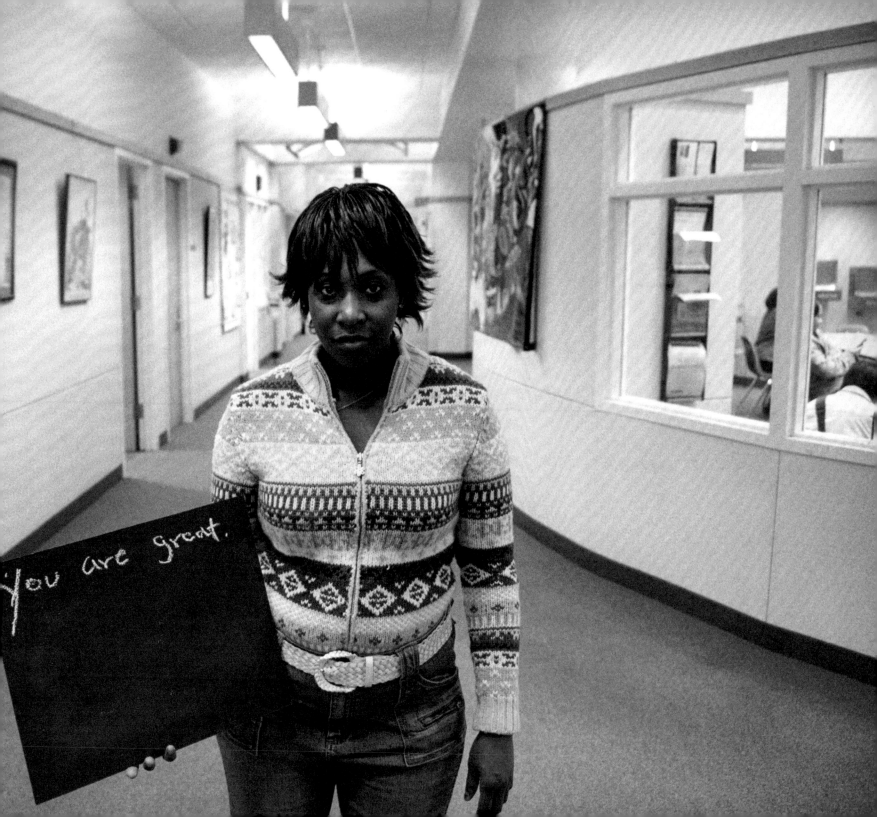

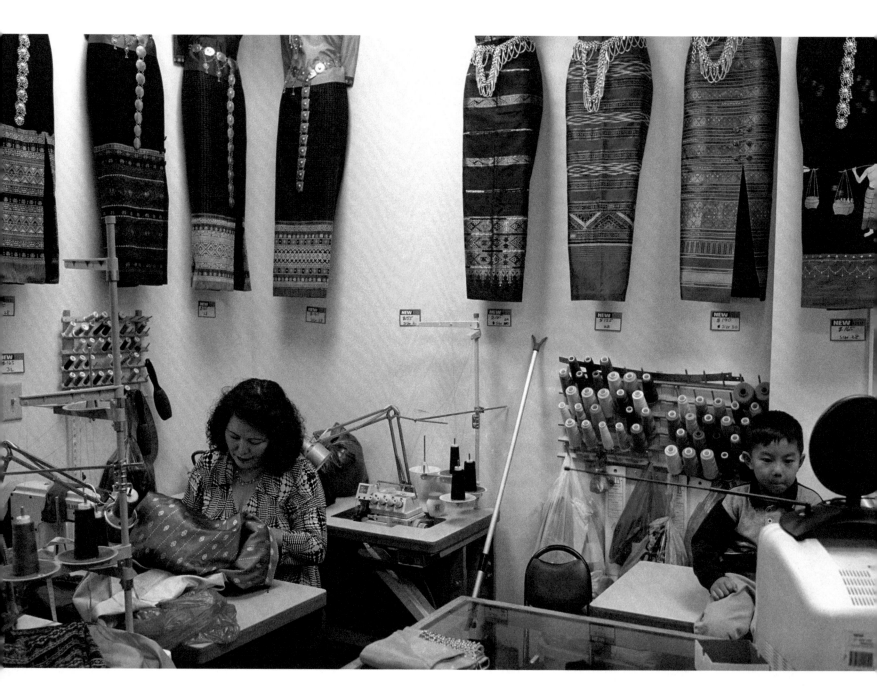

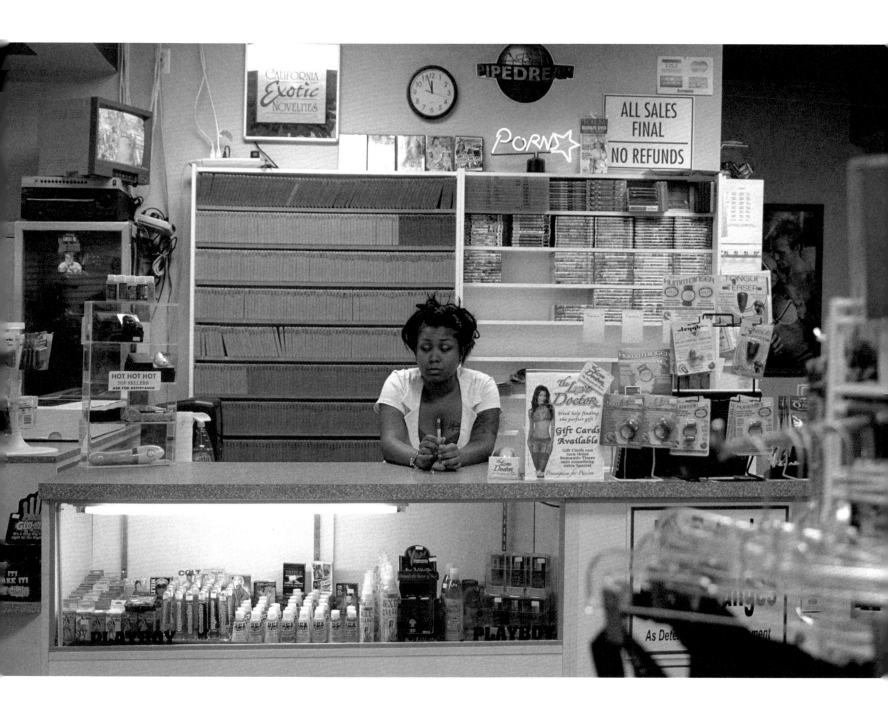

TIMELINE
The University Avenue Project

THE UNIVERSITY AVENUE PROJECT'S development has spanned nearly four years, from 2007 to 2010, and has cost more than $350,000 to produce. Beyond cash, it has required scores of volunteers, thousands of staff hours, and generous donations of material, time, and expertise. From an initial concept of small-scale slide-shows, it has expanded to installations in more than eighty street-front venues and an outdoor projection spectacle with regular cabarets, artist dialogues, and a soundtrack presenting the work of local musicians. It has been created through a collaboration between the artist Wing Young Huie and the nonprofit organization Public Art Saint Paul. *The University Avenue Project* had its seeds in a park design project that began in 2004.

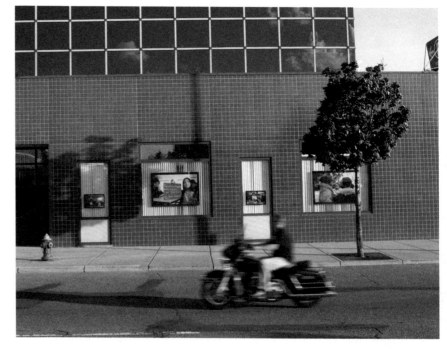

Installation view

SEPTEMBER 2004 Wing Young Huie is chosen to work with Coen+Partners landscape architects on the design of Dickerman Park on University Avenue in Saint Paul. The project, an initiative of the Friends of the Parks and Trails of Saint Paul and Ramsey County, University UNITED, and Saint Paul Parks and Recreation, seeks to revitalize the only park along the length of University Avenue in Saint Paul. Christine Podas-Larson, founder and president of Public Art Saint Paul, is a member of the task force.

MARCH 2006 Plans for Dickerman Park, including mural-size photographs by Wing, are unveiled.

APRIL–AUGUST 2007 Christine brings up the idea of expanding Wing's work on University Avenue beyond Dickerman Park. Wing at first is reluctant to take on another *Lake Street USA*–scale project. Christine proposes to Wing that Public Art Saint Paul apply for a grant from the Chicago-based Joyce Foundation, which provides $50,000 for Midwest arts organizations to commission new work from artists of color.

NOVEMBER 2007–DECEMBER 2009 The Joyce Foundation notifies Public Art Saint Paul and Wing Young Huie that *The University Avenue Project* has been selected for a Joyce Award. The original proposal calls for twelve small, window-front slideshows, one every half mile. It also proposes an outdoor community slideshow and monthly local talent performances in parking lots and available spaces. Wing photographs the life of University Avenue over its entire six-mile length in Saint Paul. Having learned from previous endeavors that he must veer off the main thoroughfare to get the real picture of a neighborhood, Wing photographs not only on the street but also in University Avenue schools, churches, restaurants, bars, and barbershops and at family celebrations. He captures thousands of images and the stories that go with them. He begins to incorporate chalkboards into his photos.

JANUARY 2009–MAY 2010 The concept for the project is transformed and the production team is formed. Wing realizes that the sheer scale of University Avenue is vast—much bigger than Lake Street. He sees the need for the exhibition to have both a day- and night-time presence. Wing expands the plan to include print photographs installed in dozens of street-front venues, clustered in places with high circulation. He proposes a number of large-scale murals at critical nodes and vista points.

Wing and Public Art Saint Paul assemble the full production team, including staff, website designers, education consultants, college interns, and others. Ethnomusicologist Dr. Allison Adrian and Jade Tittle from local radio station 89.3 The Current work with Wing and others to compile a soundtrack for the projections.

Christine brings in Steve Dietz, creative director of Northern Lights.mn, to consult about the issue of projection. In the vastness of the Avenue, the small storefront slideshows seem inadequate. Steve recommends scaling up to spectacle size, including an outdoor movie theater in a vacant lot on University. He develops a plan for screens to be mounted on cargo containers. After months of surveying possible open lots and approaching property owners, Christine spies a notice in a local paper of the Saint Paul Housing and Redevelopment Authority's purchase of a vacant car lot just west of Hamline Avenue. She contacts city councilmember Russ Stark, and with his support Public Art Saint Paul secures permission from the city to use the site for the duration of the exhibition.

Pro bono partners step up to the plate. Steve secures the design services of Meyer, Scherer & Rockcastle, LTD, architects to design the site. The plan calls for powerful projectors, and Christine reaches agreement with the Saint Paul RiverCentre to jointly purchase the needed equipment. DART Transfer and Storage agrees to supply cargo containers, and Frank Frattalone lends the service of a crane to lift them into place. Flannery Construction builds out the site. The 3M Foundation provides a generous grant to print and install large-scale photographic murals. Fast Horse, a public relations firm, provides its services to reach media nationwide, and the *Saint Paul Pioneer Press* offers free advertising space.

Wing's other major projects, *Frogtown: Portrait of a Neighborhood* and *Lake Street USA,* were documented in books. In 2009, the Minnesota Historical Society Press expresses interest in *The University Avenue Project.* Through discussions with Wing and Christine, the plan evolves for a two-volume book, one to be ready as a catalog for the exhibition opening in May and the other to document people experiencing the exhibition once everything is in place. Work on the books begins in summer, and the first volume goes to press early in 2010.

MAY 1, 2010 *The University Avenue Project* opens, with over 250 photographs installed in eighty venues over six miles. More than six hundred people attend the show's premiere at the Project(ion) Site. The project will remain in place through October 31, 2010, with Wing holding regular community dialogues and cabaret performances scheduled at the Project(ion) Site.

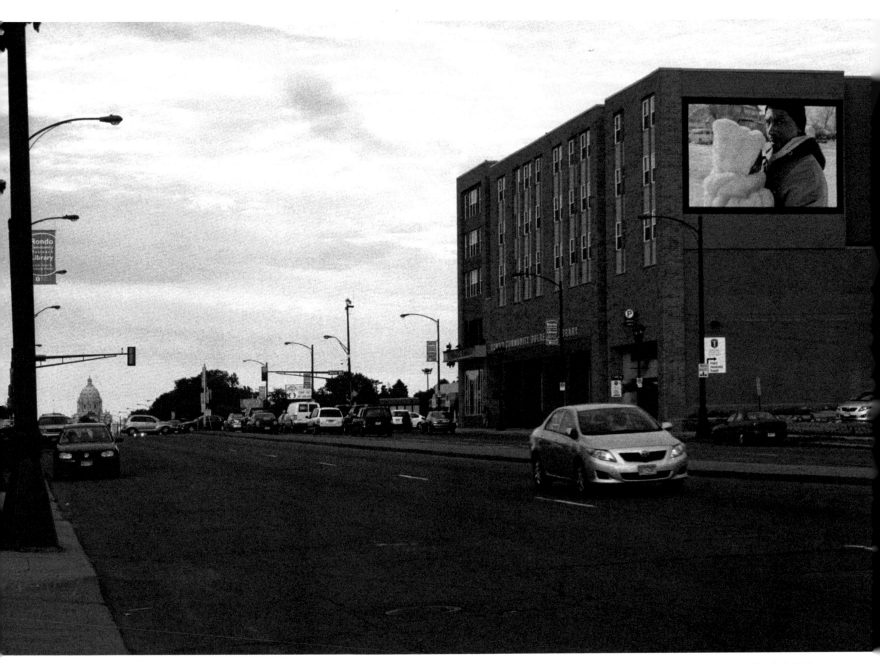

Installation view. Photo by Emily Cox

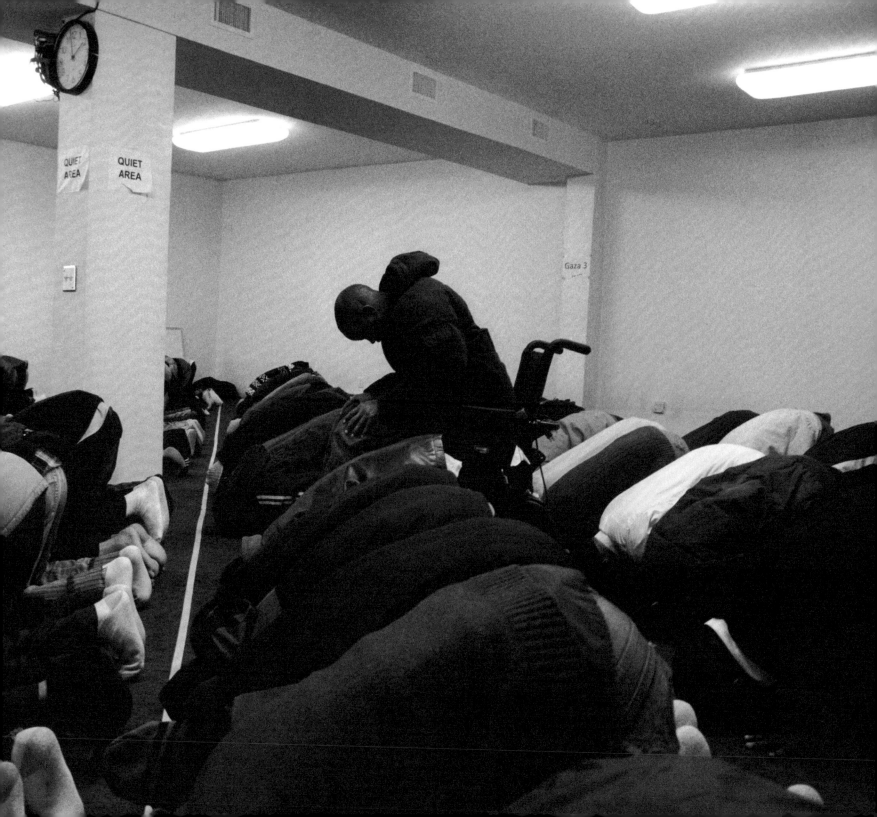

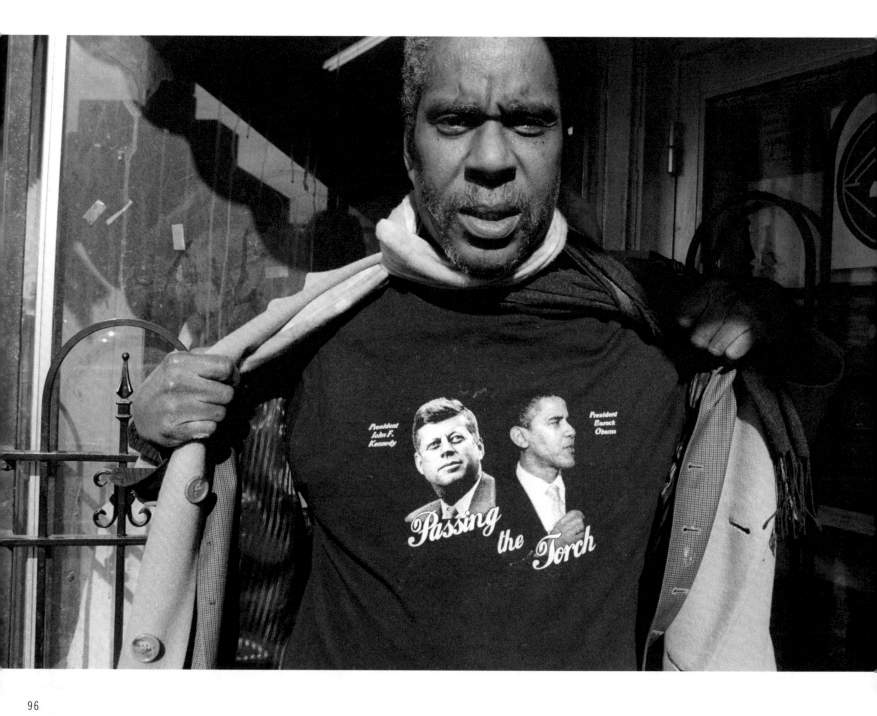

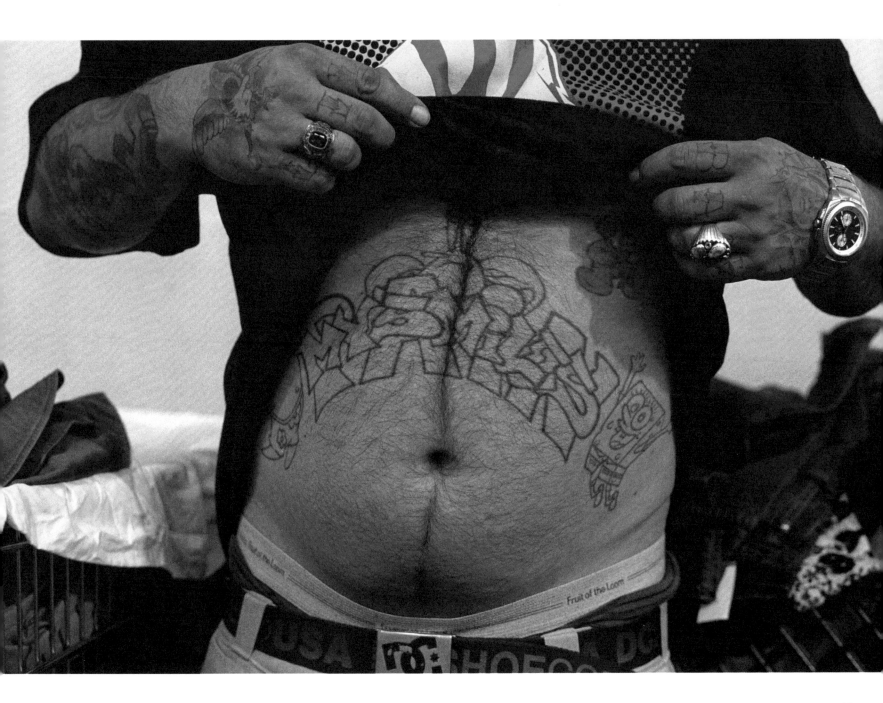

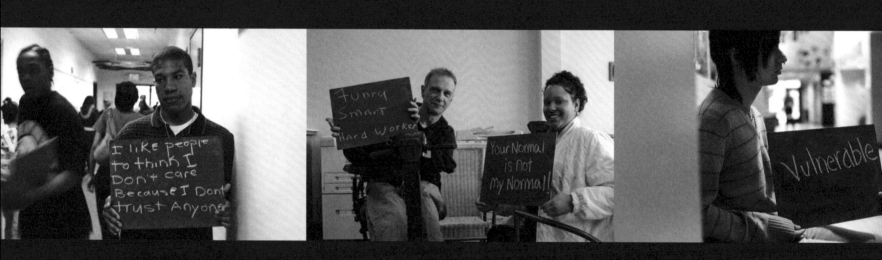

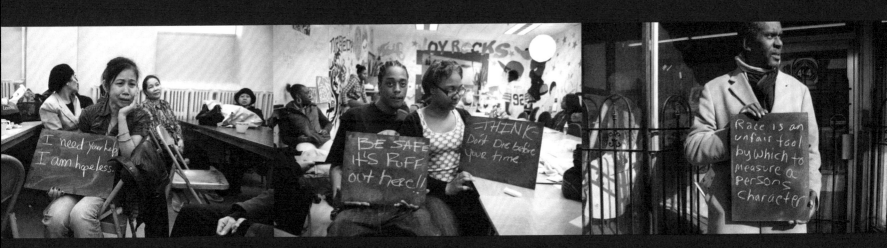

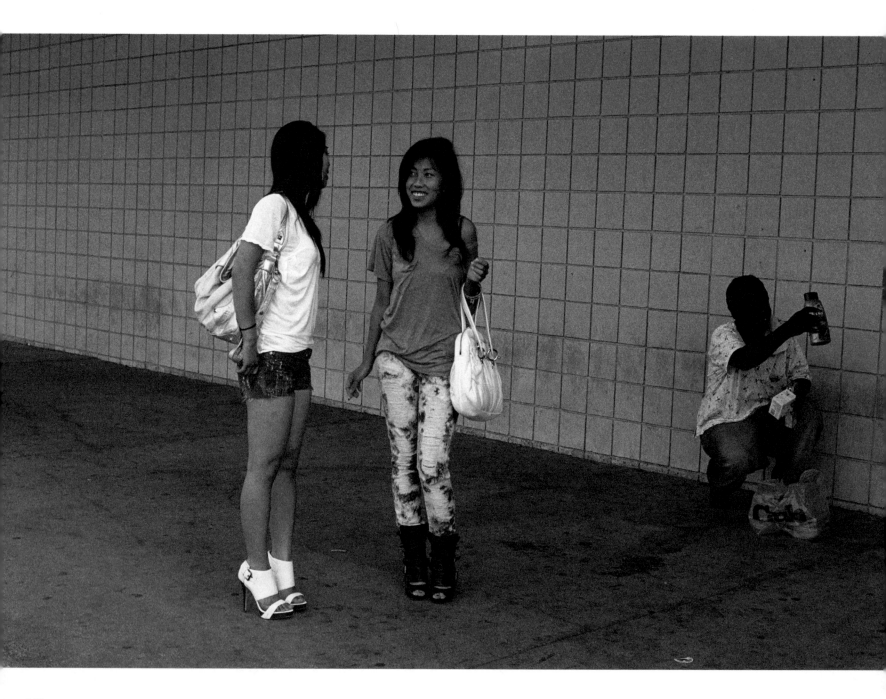

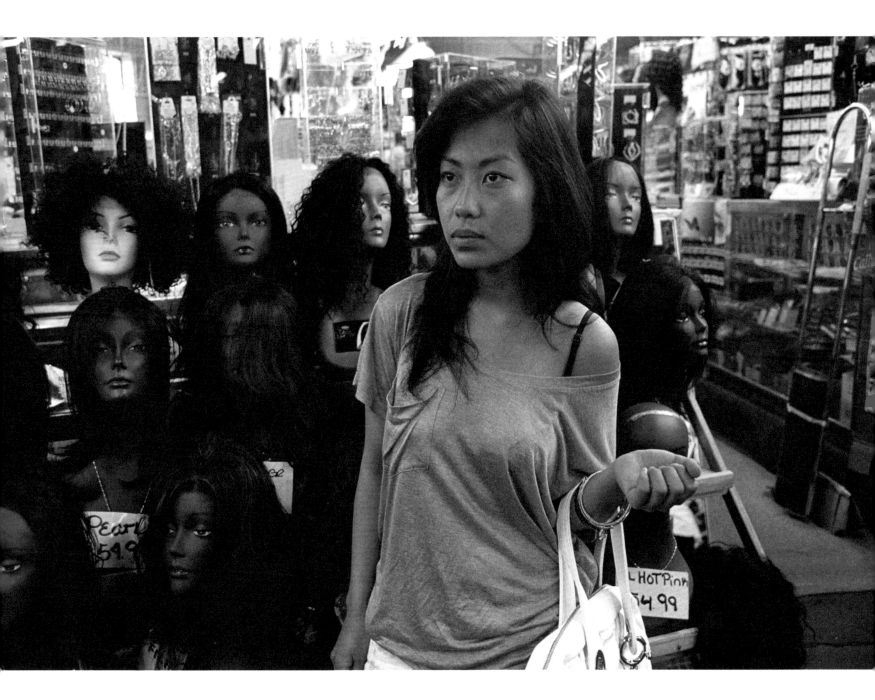

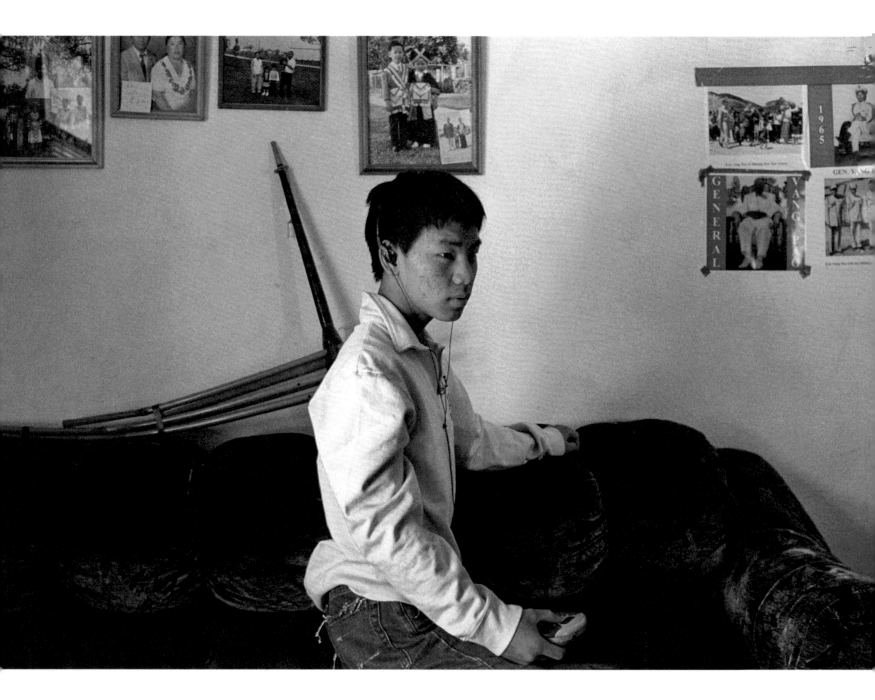

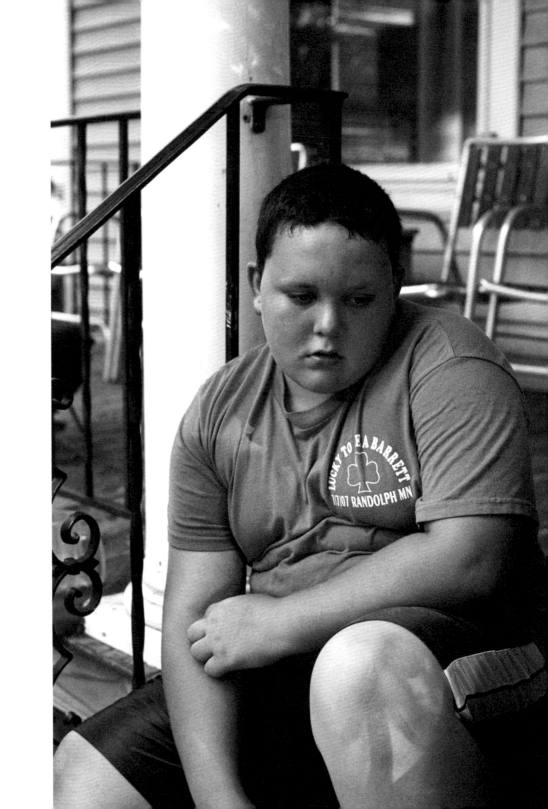

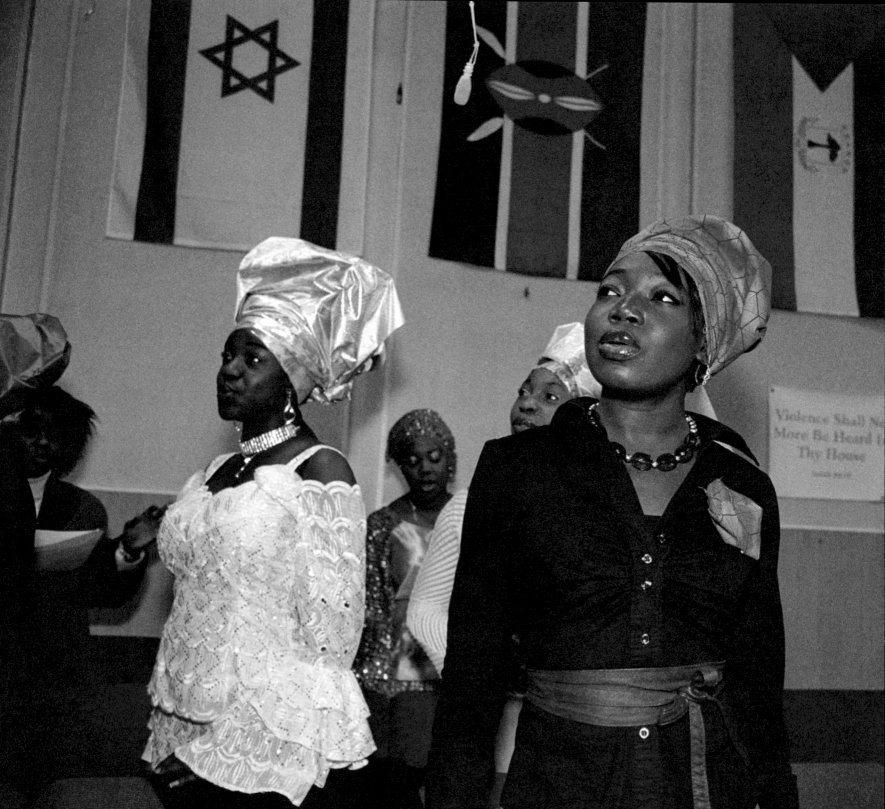

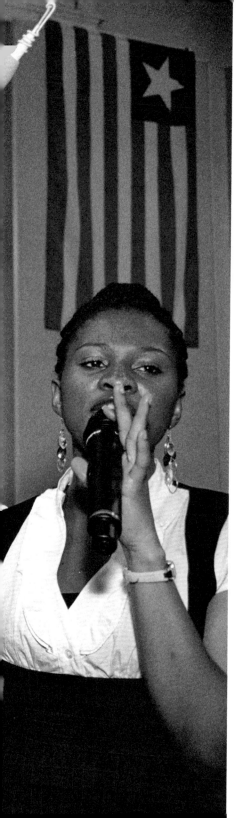

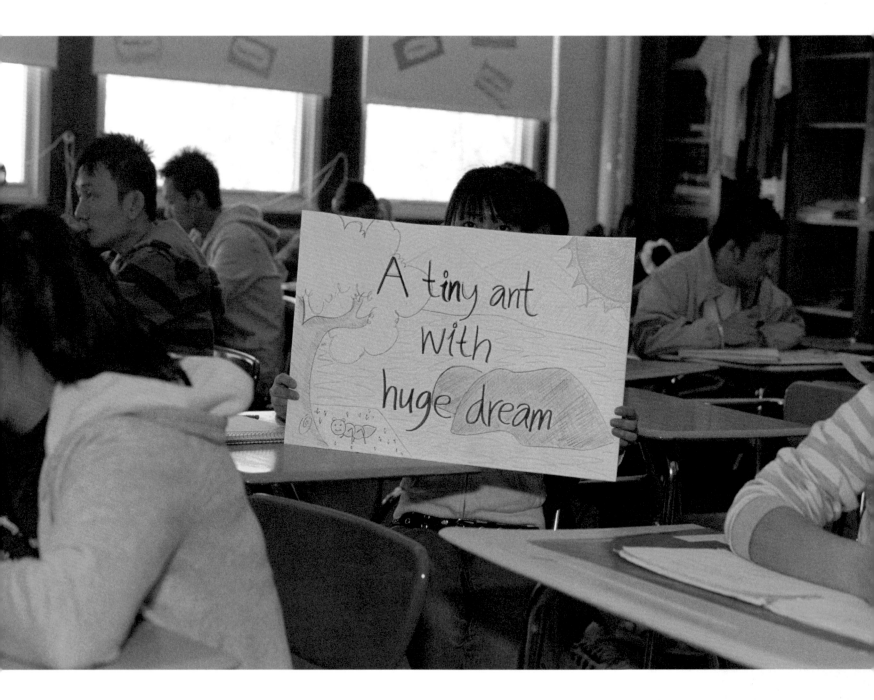

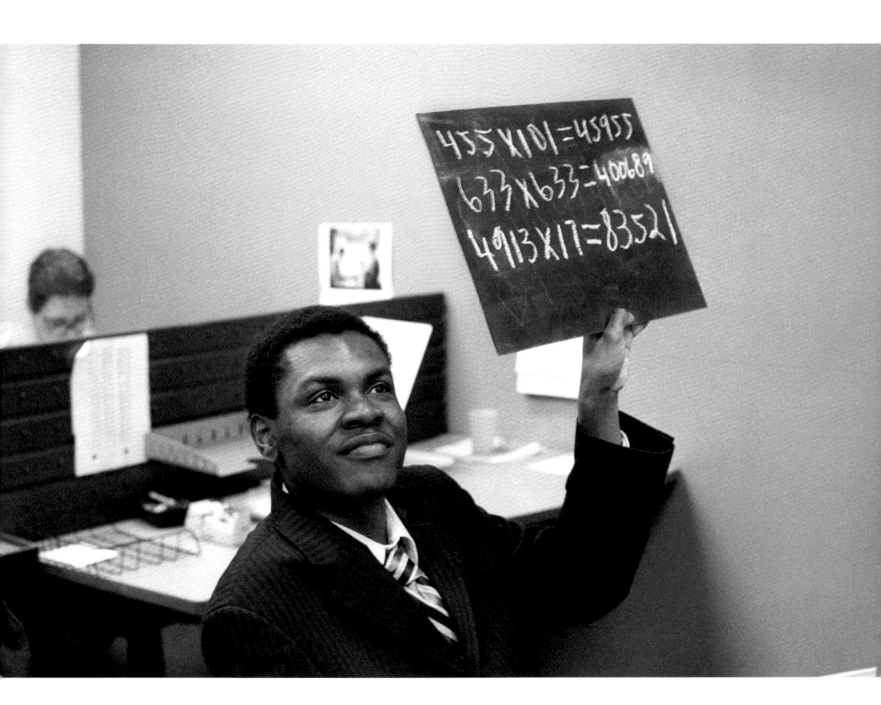

455 X101 = 45955
633 X 633 = 400689
4913 X 17 = 83521

"I THINK THIS WORK IS BEAUTIFUL. FILLED WITH EMOTION. I WANT TO HUG THESE PEOPLE. **I WANT TO MAKE SOME SORT OF DIFFERENCE.**"
—ANONYMOUS COMMENT

Installation view. Photo by Coreana Fairbanks

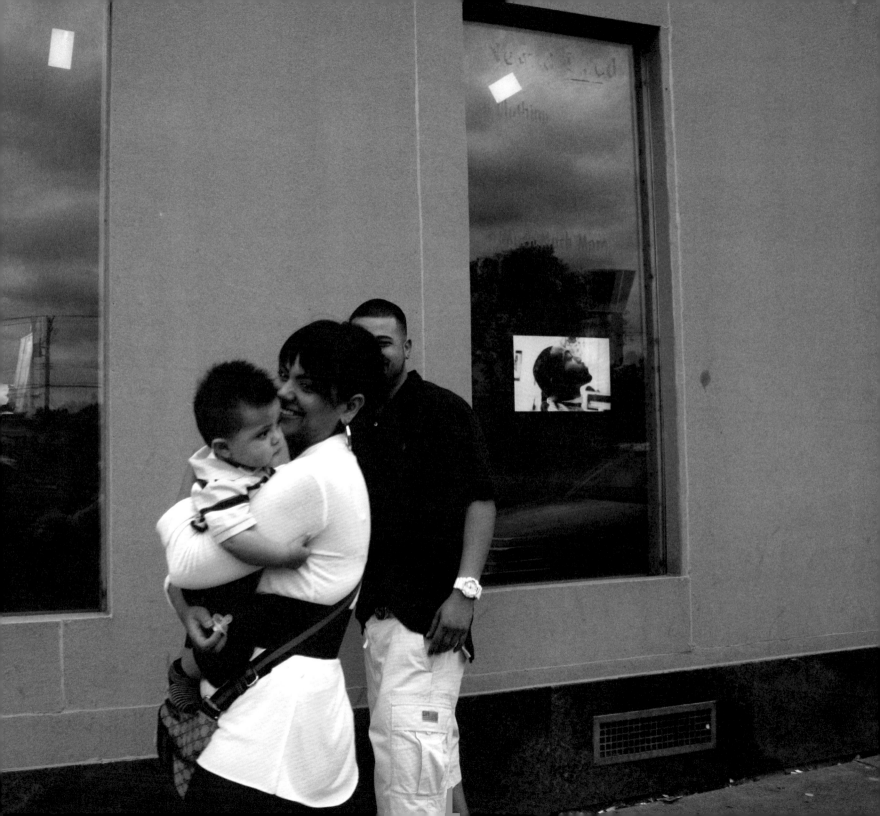

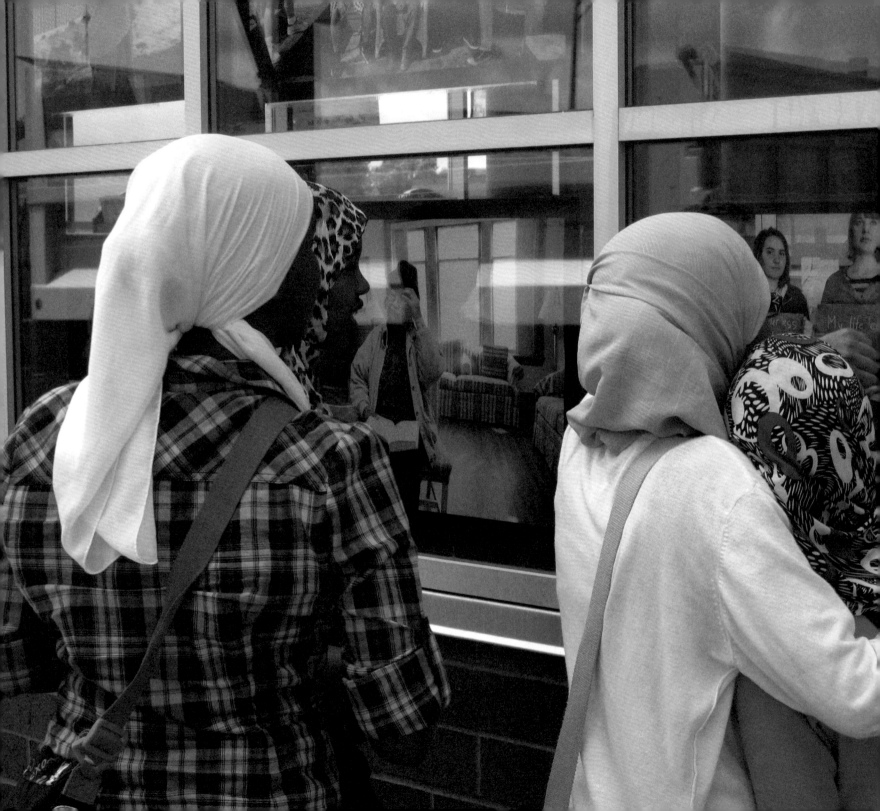

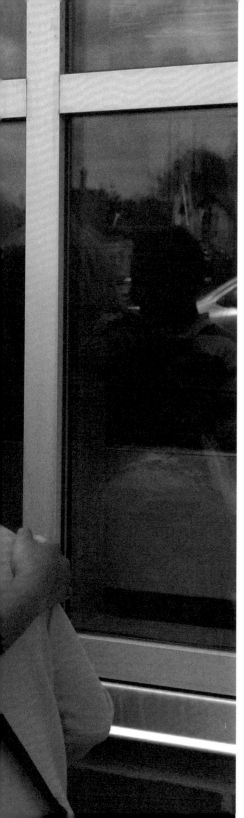

Installation view

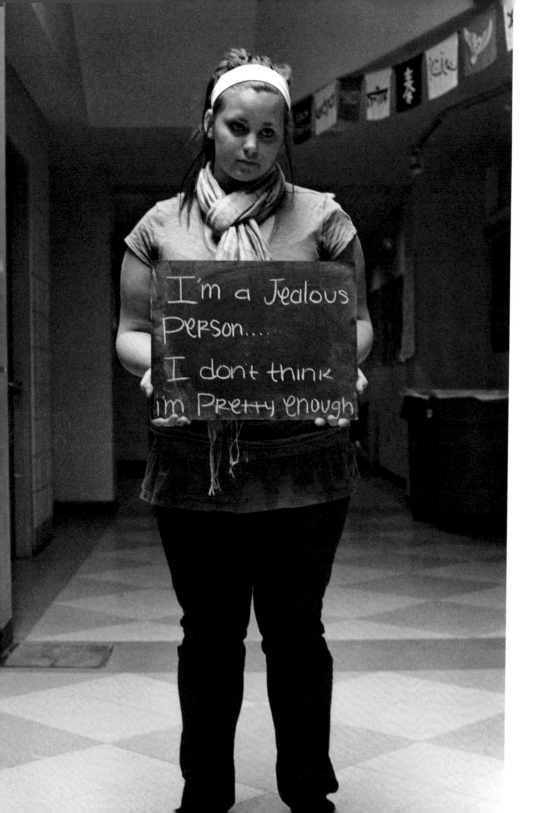

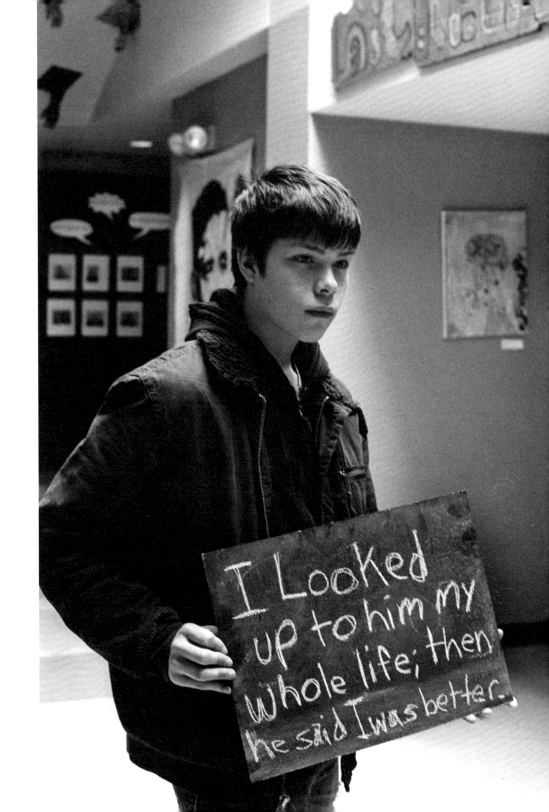

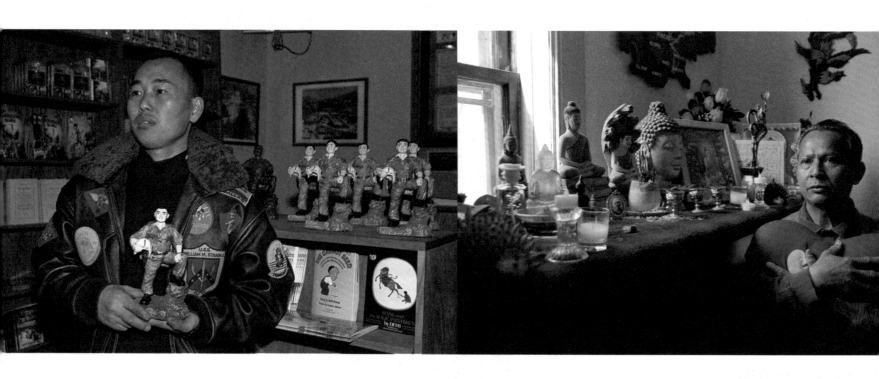

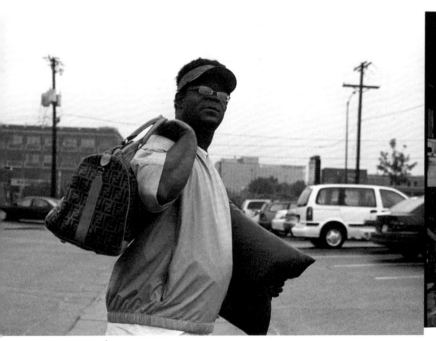
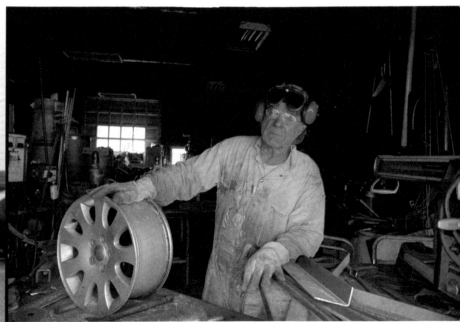

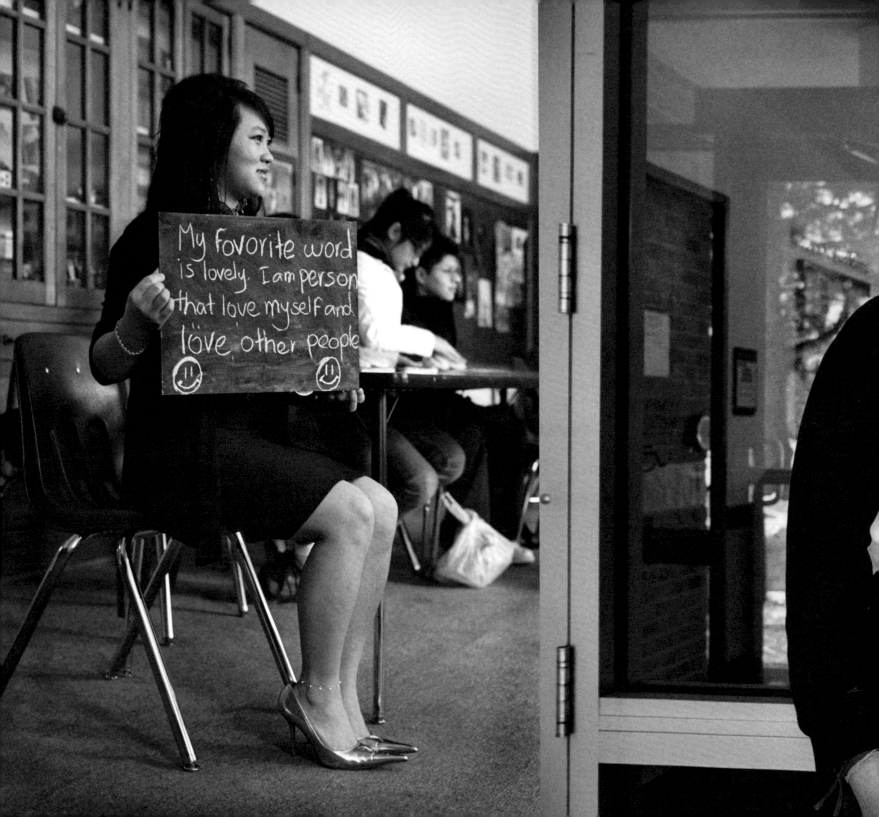

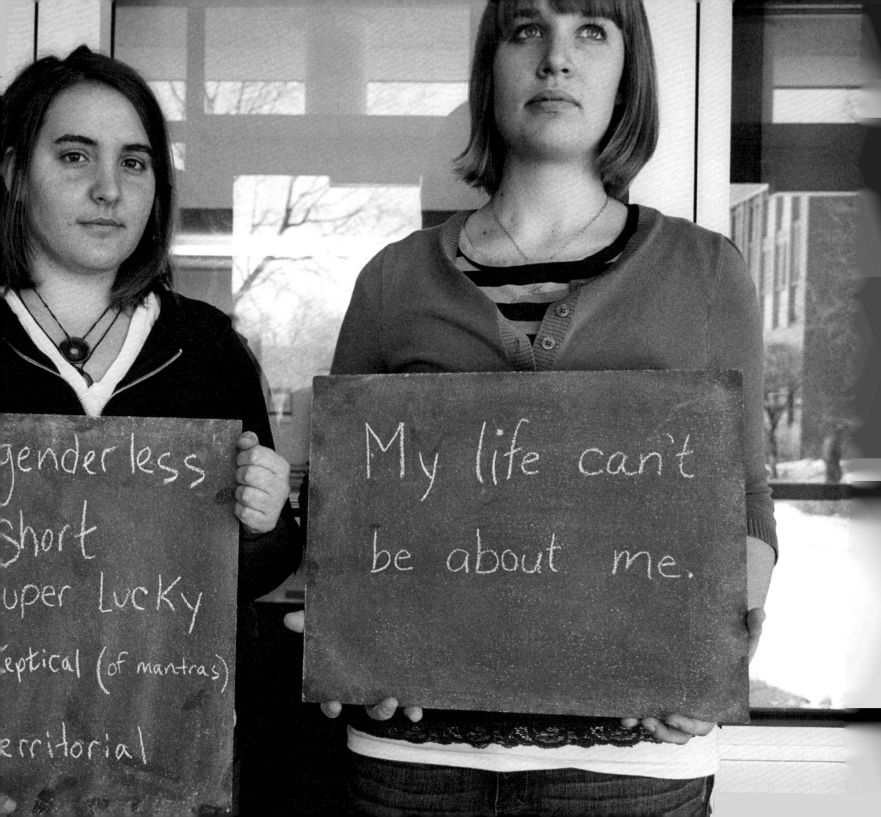

118

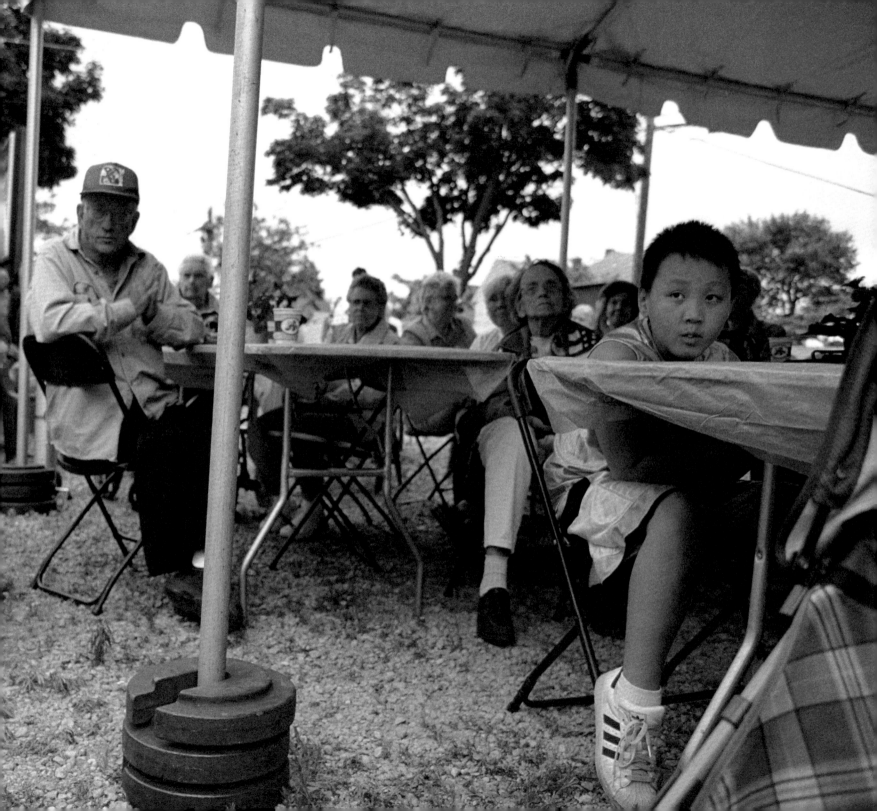

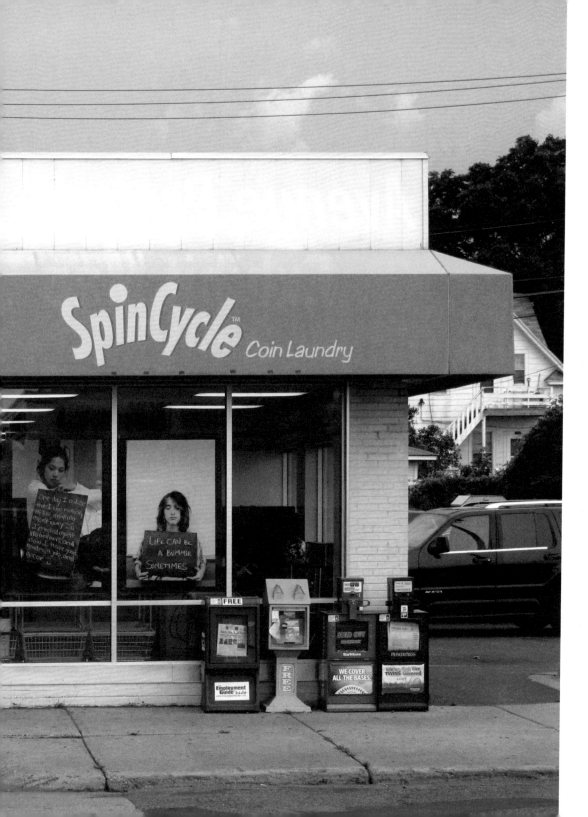

Installation view

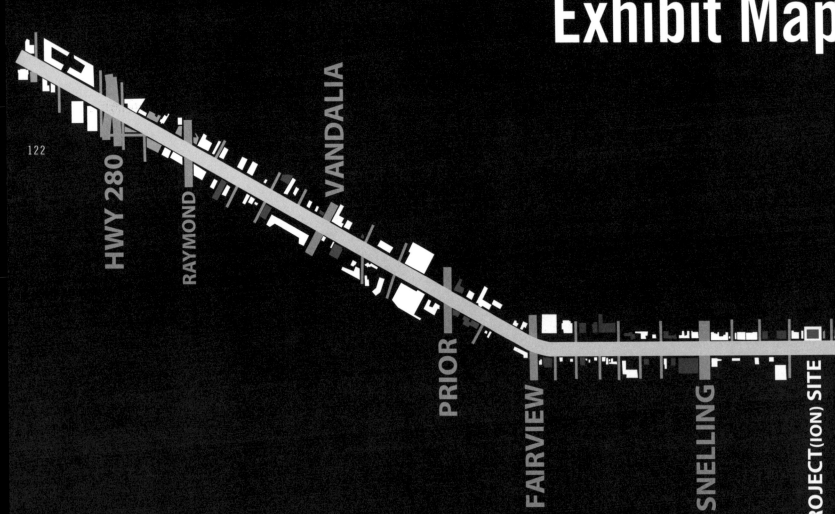

The University Avenue Project
Exhibit Map

Snap Fitness
Dunn Bros Coffee
Allegra Prints & Images
Chocolat Celeste
Martha's Gardens
Plaudit Design
SOS Furniture
The Edge Coffee House
Twin Cities Aikido Center
US Bank
Midtown Commons
Dow Building
Wright Building
Park Midway Bank
SPI Printing & Graphics
Sign-A-Rama
MTS Business Solutions
The Realty Matrix
Eclipse Records
Keystone Community Services
Swank Furniture
Weber & Troseth Co
Merkato Grocery Store
Hotel Furniture Liquidators
Impressive Print
Avalon School
Liberty Tax Service

Marsden Building
Milbern Clothing Company
Kim Huoy Chor Restaurant
Ax-Man Surplus
Metro Dental Care Clinic
Midway Uniform
Spin Cycle Laundromat
Sprint Shop
The Town House Restaurant
Midway Chevy
Midway Training Services
Whitaker Buick
Gordon Parks School
Kimble Chiropractic
St. Paul City Church
Central Corridor Resource Center
St. Paul Creative Arts School
Hubbs Learning Center
Shear Pleasure Salon
Five Star Tattoo Shop
Williams Store Inc.
Model Cities of St. Paul
Thu's Beauty Salon
Que Nha Restaurant
Ngon Restaurant
Aurora St. Anthony NDC
Lifetrack Resources

ABC Insurance
UABA/U-Plan/University United
Saigon Restaurant
J V Alterations
Shalom Salon
Sugarush
China One
A-1 Vacuum
Western Bank
Shuang Hur Asian Market
Hynan Chiropractic
Rondo Community Outreach Library
Legacy Management
Asian American Press
Anh's Hairstylists
Lao Family Community
Bangkok Thai Deli/Supermarket
Team Personnel Service
Community Financial Center
Hmong Minnesota Professionals
R&C Greater Midwest Insurance
League of MN Cities

LEXINGTON VICTORIA DALE WESTERN RICE

Credits and Acknowledgments, Volume Two

Wing Young Huie, Artist

Public Art Saint Paul, Producer
Christine Podas-Larson
Ashley Hanson
Nic Hager
Abe Gleeson
Emily Cox
Linnea Larson
Joe Borer

Marketing and Public Relations
Fast Horse
 Jörg Pierach
 John Reinan

Project(ion) Site
Northern Lights.mn
 Steve Dietz
 Jeffrey Scherer
Meyer, Scherer & Rockcastle, LTD (MS&R)
 Matthew Kruntorad
 Kristilyn Vercruysse
Courtney Kruntorad, cm.k design
BKBM Engineers
 Ronald J. LaMere, P.E.
 John C. Timm, P.E.
Frank Frattalone, Frattalone Companies
Brad Oren, DART Transfer and Storage, Inc.
Flannery Construction
 Gerry Flannery
 Dan Lindofer
 Paul Ivers
 Robert Vasser
John Hock, Franconia Sculpture Park
Kent Larson

Holly Monnett, The Town House Bar
John Monto
Over 200 community volunteers

Publication
Minnesota Historical Society Press
 Pamela McClanahan
 Daniel Leary
 Shannon Pennefeather
 Mary Poggione
 Alison Aten
 Gwenyth Swain, freelance editor

Photograph Production
Jerry Mathiason
Universal Color Photographic & Digital Imaging
Digigraphics-Photos Inc.

Music Curators
Dr. Allison Adrian, St. Catherine University
Jade Tittle, Tinderbox Music and 89.3 The Current

Identity and Book Design
Aaron Pollock

Website Engineering
Dan Gustafson, BAI Solutions
Steve Appelhans

Education Consultants
Todd Richter, Roseville Area Middle School
Mary Dorow, Saint Paul Public Schools

Volunteer Coordination
Ann Bellows

Community Partners

Peggy Lynch, Friends of the Parks and Trails of St. Paul
 and Ramsey County
Brian McMahon, University UNITED
Linda Winsor, University Avenue Business Association
Lori Fritts, Midway Chamber of Commerce
Michael Jon Olson, Hamline Midway Coalition
Dan McGrath, Take Action Minnesota
Western Bank
 William Sands
 John Bennett
Steve Wellington, Wellington Management, Inc.
Jim Miller, James Miller Investment Realty Co.
Jim Ibister, Saint Paul RiverCentre
Patrick Seeb, Saint Paul Riverfront Corporation
Archie Givens, Jr., Legacy Management & Developmen
 Corporation
Jay Benanav
CVS Caremark
Alan L. Peterson
James A. Stolpestad, Exeter Realty Company
The League of Minnesota Cities
Snap Fitness and Dunn Bros Coffee
Cheryl Frenette, Vomela Specialty Company
Eighty street-front venues for photographic display over
 six miles of University Avenue

City of Saint Paul

Mayor Chris Coleman
Housing and Redevelopment Authority
 Councilmembers Melvin Carter III and Russ Stark
Department of Public Works
Saint Paul Public Libraries
 Rondo Community Outreach Library

Public Art Saint Paul Board of Directors

Edward F. Fox, Board Chair
Craig Amundsen
Sue Banovetz
Bob Bierscheid
Zachary Crain
Tom Eggum
John Fedie
James Garrett, Jr.
David King
Peter Kramer
Finette Magnuson
Joan Palm
Marilyn Porter
Susan Price
Andrea Stimmel
Imogene Treichel
Yamy Vang
Mark Wickstrom
Ramsey County Commissioner Toni Carter, Ex Officio
Minnesota State Representative Cy Thao, Ex Officio

Interns

Sarah King, University of Saint Thomas
Coreana Fairbanks, Minneapolis College of Art & Design
Dayna Besser, College of Visual Arts
Mitch Anderson

Participating Schools

Hubbs Center for Lifelong Learning
Creative Arts High School
Gordon Parks High School
International Academy—LEAP
AGAPE High School
Avalon School
New Spirit School

Dugsi Academy
High School for Recording Arts

Sponsors

The University Avenue Project is presented by Public Art
Saint Paul with major support from a Joyce Award of the
Joyce Foundation, a publication grant from the Elmer L.
and Eleanor J. Andersen Fund of the Minnesota Historical
Society, funding from the John S. and James L. Knight
Foundation, The Saint Paul Foundation, F. R. Bigelow
Foundation, Travelers Foundation, Huss Foundation,
Hardenbergh Foundation, Mardag Foundation, Katherine
B. Andersen Fund, George Mairs, Bruce A. Lilly, Kent and
Ariel Dickerman and Dickerman family members, and
in-kind support from the 3M Foundation, Fast Horse,
Meyer, Scherer & Rockcastle, LTD (MS&R), Frattalone
Companies, and the Pioneer Press/TwinCities.com and
with special support from the family and friends of Molly
Gleeson.

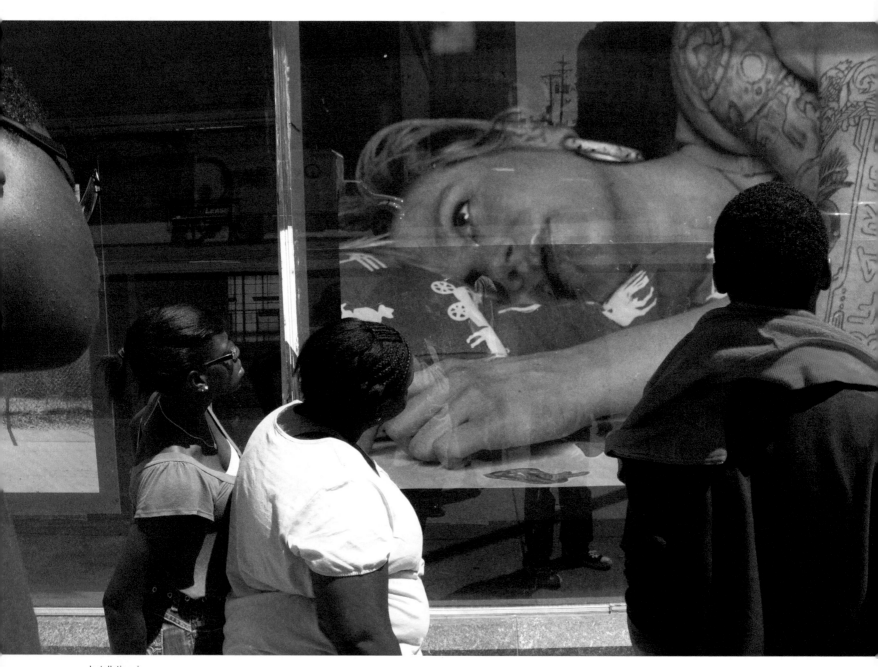

Installation view

Soundtrack

Participating Artists:

Aaron & the Sea	The Okee Dokee Brothers
Abre Ojos	The Pachamama Band
The Abstract Pack	Charlie Parr
Brooke Aldridge	Ryan Paul & the Ardent
Erik Brandt	Pooja Goswami Pavan
Bring Prudence	Pear (Harley Patton)
Willie Cherry	Pert' Near Sandstone
Cloud Cult	Rak-smey Khemera
EJ Davila	The Roe Family Singers
Martin Devaney	Romantica
The Eclectic Ensemble	The Sextons
Tim Ericksen	The Spaghetti Western String Co.
Gigie Blu (Angela Hardy)	The Swahili Choir at Holy Trinity Lutheran Church
Ben Glaros	22 Chemicals
Tom Grotewohl	Alicia Wiley
David Hanners	
Heatherlyn	
Hilltribe	
Mary Beth Huttlin	
Junkyard Empire	
Kristoff Krane	
Brian Laidlaw	
Brett Larson	
Tou SaiKo Lee	
Larry Long	
The Mad Ripple (Jim Walsh)	
Mandrágora Tango	
M.anifest	
Siama Matuzungidi	
The Minnesota Sacred Harp Singers	
Lynsey Moseman	
Erin Muir	
The Muskies	

127

The University Avenue Project soundtrack is available for download from Noiseland Industries.

1. Go to **www.soundtrax.com**

2. Enter the eight-letter, case-sensitive code printed below

3. Click **"GET YOUR MUSIC."**

KBuyMrta

611T15949

Maryland Institute, College of Art
The Decker Library
1401 Mount Royal Avenue
Baltimore, MD 21217

131713

MD INSTITUTE COLLEGE OF ART

10079692

F 614 .S4 H86 2010 v.2
Huie, Wing Young, 1955-
The University Avenue
Project

Maryland Institute, College of Art
The Decker Library
1401 Mount Royal Avenue
Baltimore, MD 21217

For more information,
see www.theuniversityavenueproject.com

© 2010 by the Minnesota Historical Society. All rights
reserved. No part of this book may be used or reproduced
in any manner whatsoever without written permission
except in the case of brief quotations embodied in criti-
cal articles and reviews. For information, write to the
Minnesota Historical Society Press, 345 Kellogg Blvd. W.,
St. Paul, MN 55102-1906.

www.mhspress.org

The Minnesota Historical Society Press is a member of
the Association of American University Presses.

Manufactured in the United States of America

10 9 8 7 6 5 4 3 2 1

∞ The paper used in this publication meets the mini-
mum requirements of the American National Standard
for Information Sciences—Permanence for Printed
Library Materials, ANSI Z39.48–1984.

Design by Aaron Pollock
Composition by Daniel Leary & Phoenix Type
Printed by Print Craft, Inc.

International Standard Book Number
ISBN 13: 978-0-87351-794-2 (paper)

Library of Congress Cataloging-in-Publication Data

Huie, Wing Young, 1955–

 The University Avenue Project : the language of urbaism:
a six-mile photographic inquiry / Wing Young Huie.

 v. cm.

 ISBN 978-0-87351-782-9 (v. 1 : paper : alk. paper) —
 ISBN 978-0-87351-794-2 (v. 2 : paper : alk. paper)

 1. University Avenue (Saint Paul, Minn.)—Pictorial
works—Exhibitions. 2. City and town life—Minnesota—
Saint Paul—Pictorial works—Exhibitions.
3. Street life—Minnesota—Saint Paul—Pictorial
works—Exhibitions. 4. Cultural pluralism—Minnesota—
Saint Paul—Pictorial works—Exhibitions. 5. Saint Paul
(Minn.)—Biography—Pictorial works—Exhibitions. 6.
Saint Paul (Minn.)—Social life and customs—Pictorial
works—Exhibitions. 7. Saint Paul (Minn.)—Social condi-
tions—Pictorial works—Exhibitions. 8. Photography—So-
cial aspects—Minnesota—Saint Paul—Exhibitions. 9.
University Avenue Project (Saint Paul, Minn.) I. Title.

 F614.S4H86 2010 977.6'581—dc22 2010008722

MIX
Paper from
responsible sources
FSC® C019376